The Art of Aging

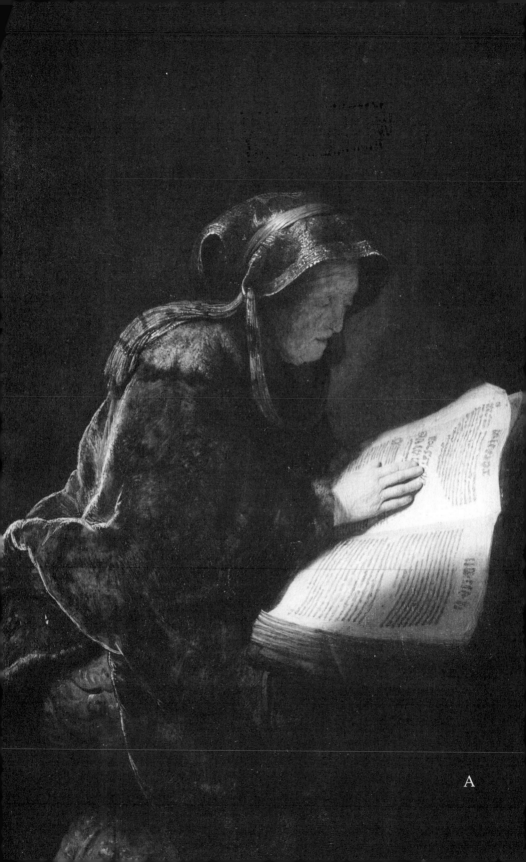

A

The Art of Aging

A Celebration of Old Age in Western Art

Patrick McKee, Ph.D.
Department of Philosophy
Colorado State University

Heta Kauppinen, Ph.D.
Department of Art
University of Wisconsin–Milwaukee

 INSIGHT BOOKS

HUMAN SCIENCES PRESS
72 FIFTH AVENUE
NEW YORK, N.Y. 10011-8004

Printed in the United States of America
987654321

Library of Congress Cataloging-in-Publication Data

McKee, Patrick L.
 The art of aging.

 Bibliography: p.
 Includes index.
 1. Old age in art. 2. Art. I. Kauppinen, Heta.
II. Title.
N8234.04M35 1986 758'.930526 86-10552
ISBN 0-89885-304-4

Contents

Acknowledgements

Acknowledgements and sincere thanks are given to the following institutions and individuals who kindly provided materials and granted permission to reproduce them in this volume.

Albertina, Vienna 15

Albright-Knox Gallery, Buffalo 36, 52

Art History Museum, Vienna 5, 17, 21, 26, 27, 42, 46, 48, 49, 64, 74, 96, 103, 107, 110, 113, 114

The Art Institute, Chicago 14

Art Museum of Turku, Finland 32, 108

Ateneum Art Museum, Helsinki 53, 93, 112

Collection of Blount, Inc., Montgomery, Alabama 88

Collection of Mr. and Mrs. Boyd George, Hickory, North Carolina 6

Collection of Mr. and Mrs. James Crook, Jackson, Mississippi 84

Collection of Mr. and Mrs. Levon Register 89

Corcoran Gallery of Art, Washington 12

The Frick Collection, New York 47

Hermitage, Leningrad 43, 57, 91

Preface

This book celebrates the interpretation of old age in Western art. The 116 pictures presented express the challenges, satisfactions, sorrows, and joys in the human experience of growing old. After a brief section on how to look at pictures of the elderly, four general aspects of old age are explored in detail. The first concerns the different ways in which people adjust to growing old, and how these alternative ways of aging have been treated in art. Next, the themes of wisdom in old age and the relationships between the elderly and other age groups in society are explained. Finally, the role of popular and ancient myths in shaping our ideas about the elderly is examined. All these themes are related to recent discoveries in the psychology and sociology of aging.

The plates give evidence of the profound insights of artists into the many aspects of aging discussed in the text. The comments accompanying the plates provide an extension of the major text and encourage the reader to create his own interpretation of the adventure of aging. By looking at the art works and re-

flecting on the text the reader can achieve a more positive and optimistic attitude toward aging and the elderly.

The book will be of interest to social workers, family counsellors, nurses, medical doctors, teachers, clergy, therapists, and others who work in the expanding field of geriatrics. It will also be useful to gerontologists, sociologists, psychologists, and their students. Since the book provides a fresh perspective on many of the masterpieces of Western painting, it will also interest art historians. Finally, the book will bring pleasure and enlightenment to members of the general public. For younger adults, it will provide accurate, understandable access to the world and experiences of older adults. For those who are approaching or experiencing old age, it will provide a mirror in which the inner grace and moving human drama of their own lives are captured and reflected.

PART I

1. Old Age in Art

The Beauty of Age

The human experience of growing old has always had compelling interest for artists. More than half of Rembrandt's paintings depict old age. Rubens and Daumier also devoted a very large percentage of their paintings either entirely or partially to old age. Even among artists who have not devoted a large number of paintings to the subject, some of the most memorable works have been images of elderly people. This is true, for example, of Ghirlandaio, La Tour, and Leonardo.

It is not surprising that artists have taken such interest in the process of growing old. It is among the most profound and meaningful experiences we can have. Like adolescence, old age is a time of basic developmental changes in our lives and personalities. Many of those changes, such as the growth of wisdom, the crisis overcoming despair, life review, changes in social status, and others have been explored with great sensitivity in art.

Many of the experiences we have in growing old are positive and rewarding. Others are painful and destructive. But virtually all of them have deep human significance. In growing old our noblest human qualities are put to the test. Courage to face a relatively unknown and threatening future, the capacity to hope for the best when things go wrong, the toughness to endure catastrophic losses, and the wisdom of long experience of life—these and other qualities of the human spirit are more clearly seen in the faces, expressions, and gestures of elderly people than in any other age group. The power to express these qualities is what gives the aging human face and body such arresting visual drama and interest. And it is this that has so consistently drawn artists to portray the elderly in paintings.

What to Look for in Pictures of the Elderly

In representing old age artists cannot help revealing their basic ideas about it. Just by selecting old age or an elderly person as subject the artist attributes some significance to aging. But beyond this, in art as in other fields of inquiry, it is impossible to describe or to represent any subject completely. So artistic representation of the aged requires either conscious or unconscious choice of some aspects of aging as more worthy of attention than others. This selection inevitably reveals an underlying idea of what aging is really like and therefore often indicates many of the artist's thoughts, attitudes, and feelings about it.

The French philosopher Michel Philibert has identified several criteria by which we can identify an artist's ideas about the nature of the aging process and his underlying assumptions, feelings, and attitudes about it. These criteria can be stated in terms of the following questions:

1. What role does the artist attribute to the physical changes of aging in the image of the elderly person which he creates? Does the artist believe that in the overall process of

growing old physical changes have a primary role? Or does the artist recognize that changes that occur on other levels, such as cognitive, emotional, social, and spiritual levels, are also important in the aging process? How does the artist conceive the relationship between the changes that occur on these various levels and their relative importance?

2. Does the artist present aging primarily as decline, a process of destruction, degradation, and deterioration, or as an opportunity for improvement in the development of the aging person's life?

3. Is "aging" presented as something that is coextensive with the entire span of life, or is it presented as limited to the final period of life?

4. Is aging presented as a necessary, unavoidable calamity which we must submit to and endure, or as a process that can be to some extent controlled and turned to a constructive purpose?

5. How does the artist present the relation between aging and death? Is old age presented as nothing more than waiting around to die? Is the nearness of death in old age represented as increasing or diminishing the importance and value of life in old age?

6. Is the aging process seen by the artist as leading to social growth or social contraction? Are elderly persons seen by the artist as having importance for others? Is the elderly person seen as having a social role or as making some positive or negative difference in society? If so, what is the role that is seen as appropriate for the elderly, and what is the difference that their lives are seen as making to society? How does the artist conceive the relations between the generations—between the elderly and other age groups?

Using these questions to analyze the images of aging in paintings and the meanings those images express leads to the identification of two very different conceptions of the nature of the aging process which are opposed to each other, and in terms of which the many different artistic images of aging can be at least partially understood.

Good and Bad Aging

First there are images that emphasize the predominantly physical changes in the aging process and its negative, terminal, degenerative, and decremental aspects. Second, there are images which emphasize the sociocultural dimensions of aging, treat aging as coextensive with the entire life span, as to some extent controllable rather than overwhelming or inevitable, and which look on aging as offering opportunities for further inner development and growth.

This opposite between two different outlooks on the nature of aging is not limited to art. It is also found in poetry, novels, and plays. An example from poetry is found in the following contrasting poems. The first interprets old age as a desirable experience of exciting challenge and adventure.

> As the bird trims her to the gale,
> I trim myself to the storm of time,
> I man the rudder, reef the sail,
> Obey the voice at eve obeyed at prime:
> "Lowly faithful, banish fear,
> Right onward drive unharmed;
> The port, well worth the cruise, is near,
> And every wave is charmed."
>
> Ralph Waldo Emerson, *Terminus*

The second poem gives a more pessimistic view.

> The fire is out, and spent the warmth thereof,
> (This is the end of every song man sings!)
> The golden wine is drunk, the dregs remain,
> Bitter as wormwood and as salt as pain;
> And health and hope have gone the way of love
> Into the dear oblivion of lost things.
> Ghosts go along with us until the end;
> This was a mistress, this, perhaps, a friend.
> With pale, indifferent eyes, we sit and wait

> For the dropped curtain and the closing gate:
> This is the end of all the songs man sings.

Ernest Dowson, *Dregs*

The two typologies of aging we have identified are of course ideal types or paradigms of aging. No single work is likely to express all of the elements of either ideal, and many will be inconsistent as an artist simultaneously stresses one theme from the negative type and another theme from the positive. Nevertheless, the two paradigms are logically separable and useful in approaching the underlying ideas of artists about the nature of the aging process and in explaining the meanings of their individual works. The influence of these different viewpoints on the observation of old age among artists can be seen by comparing the handling of the theme of St. Jerome by Massys and van Romerswaele (pl. 5, 6). The first praises old age in both body and spirit, the second condemns it. A positive image in which social growth and inner grace visibly outweigh the physical losses of age is Ghirlandaio's *An Old Man and His Grandson* (pl. 65). Ghirlandaio's picture also records an exceptionally rich and touching emotional exchange between old and young, which derives some of its power from the grandfather's expression of spiritual fulfillment and wisdom. In La Tour's *St. Joseph, Carpenter* (pl. 66), the physical strength which can be seen in many physically, active elderly is represented. Rubens often represented the elderly not only as physically vital and strong, but as socially active and needed (pl. 107).

In contrast, Leonardo's well-known caricatures (pl. 7) of old age are confined almost wholly to the theme of physical deterioration and are uncompromisingly negative. The American artist Ivan Albright (pl. 8) has seen aging similarly as a process of physical deterioration unredeemed by any inner or outer compensating changes. Goya's later interpretations of the elderly (pl. 9, 72) are even more negative, since they add to unmitigated physical deterioration the look and gestures of hopeless mental decline.

Blindfolded Society

These negative images do not represent old age as it is. They are projections of our fear of aging and express our inability to comprehend its positive meanings. Albright's nightmarish vision expresses our fear of an old age without dignity or fulfillment. Leonardo's drawing demonstrates our readiness to see elderly people in negative caricature. Just as people once saw children as incomplete, imperfect adults, so we tend to see old people as ruined middle-aged adults. Leonardo's caricature gives expression to our fear of being seen in this way.

Images like these are admittedly disturbing. But they are important because they symbolize our tendency to see only the negative aspects of old age. This unfortunate bias in our culture has two harmful consequences. First, it reduces self-esteem among the elderly. Elderly people share the outlook of the society they live in, and tend to see themselves in the same way others see them. If an implicit bias of our culture is that old age lacks positive value and meaning, then many of the elderly will quite naturally see themselves in that way.

People who, in their youth, feel aversion toward old age, will suffer from their own prejudice when they themselves grow old. Our culture embraces many negative stereotypes of old age which are accompanied by exclusion, rejection, injustice, and other consequences of prejudice. Much of this stems from fear of growing old. And much of that fear results from our tendency to see only the negative, and to overlook the positive aspects of old age. By continuing to focus only or primarily on the negative, younger people perpetuate fear of aging and guarantee that harmful prejudices will still be around when they themselves have grown old.

The paintings reproduced below represent the interpretations by great artists of four general aspects of old age. First, artists have tried to interpret the general life situation of the elderly person: How have elderly people responded to the universal and profound experience of growing old? Second, representations of old age in art often present it as a time of wisdom and enriched human perspective. Third, artists have had much to say about relationships between the elderly and the

members of other generations and about the related question of the proper role of the elderly in society. Finally, artists have recorded the many characteristics, both good and bad, which we find easy to attribute to the elderly but which exist primarily in the mind of the beholder. These are best revealed in paintings of elderly characters in myth, religious scripture, and the literature of popular imagination.

2. Ways of Growing Old

Aging and Change

Old age is a time of frequent and profound change. Contrary to a widespread stereotype, it is not normally a period of uneventful sameness. Retirement from one's lifework, the achievement of wisdom, increased leisure time, having grandchildren and perhaps great-grandchildren, changes in physical strength and energy, loss of friends and loved ones through death, and the nearer approach of one's own death are examples of changes that old age can bring. These and other changes raise an important question for the elderly person. What is the best way to respond to the new challenges that old age brings? In short, what is the best way for people to live in their final years?

Jogging Shoes or Rocking Chair?
Styles of Aging: Activity and Disengagement

Artists have observed and interpreted a variety of ways in which people respond to the experiences of growing older. Among these, however, two styles of response have been more consistently represented in art than others. Following a convenient usage of gerontology, we may call these the "disengagement" and the "activity" styles of aging. The disengagement approach occurs when an aging person gradually withdraws from the roles, activities, and purposes of adult midlife, and substitutes in their place a style of interiority and increased concern with reflective understanding of the self. This approach is sometimes called the "rocking chair" approach to old age, because it favors withdrawing from the active life-style of middle age and increasing the amount of time spent in reflective thought. In contrast, the activity orientation consists in continued commitment to the roles, activities, and purposes of midlife. This is the approach we seem to be approving of when we urge elderly people to "stay active" and when we praise them for continuing to be productive in their careers or other activities into late life.

Representations of the activity orientation can be seen in such works as Toulouse-Lautrec's *Yvette Guilbert Bows to the Audience* (pl. 40). On the other hand, the disengagement position is suggested by Sargent's *In The Generalife* (pl. 13) and by a long history of images of St. Jerome as an old man who has withdrawn to the desert, such as those of Massys and von Romerswaele (pl. 5, 6).

When two artists observe and record the same style of aging, they nevertheless may give very different value judgments about it. The representations of St. Jerome by Massys and van Romerswaele just cited, for example, are strikingly parallel, but convey very different value judgments. Massys's St. Jerome is rendered in positive terms of approval, while von Romerswaele's figure is emaciated, skeletal, and barely human. Similar differences of attitude toward disengagement in old age can be seen by comparing the rich, rewarding interiority expressed by Dürer's *Study of St. Jerome* (pl. 15) with the emotional desolation of Gauguin's *Man with a Cane* (pl. 16).

Hazards and Blessings of Being Active

The activity orientation in old age has also been given to both approving and disapproving interpretations in art. The elderly blacksmith in Raffaelli's *Blacksmiths Drinking* (pl. 11), the artist seems to say, can work or drink with any man. On the other hand, Jordaens' *The Bean Feast* (pl. 17) seems to convey the opposite message: to persist for too long in the activities, passions, roles, and projects of midlife is to make an old fool of oneself.

An aspect of mental life in old age often attributed to the disengagement process that has been noted by some artists is what gerontologists call "normlessness." This is an attitude of reduced concern with conventional social norms and restraints, leading to greater freedom in the expression of such emotions as anger and sexual feeling.

An important class of artworks which can be read as confirming the activity perspective affirms the continuation of creative achievement in the later years. Examples are Daumier's *The Advocate* (pl. 12), and Toulouse-Lautrec's *Yvette Guilbert Bows to the Audience* (pl. 40).

A common expression of the activity theory in art is simply the favorable or at least neutral representation of the elderly carrying on with a share of the world's work. A frequent variation on this theme affirms the platonic doctrine of the philosopher-king. This is Plato's view that positions of social influence and power ought to be held only by those who have acquired wisdom about the role of values in society. According to Plato this normally does not occur until sometime after the age of fifty. Artists with sympathy for this gerontocratic view often show the elderly as occupying positions of special office and power.

The Choice Is Yours

Artistic interpretations of the activity and disengagement approaches to old age have anticipated many of the observations and discoveries of recent gerontology. In that field the activity and disengagement styles of aging have been regarded as the only real options open to most of us in advanced age,

and between which we ultimately must make a choice. Like the
great painters who have examined this aspect of aging, geron-
tologists have adopted different attitudes and made different
value judgments about it. Some have argued that the disengage-
ment of the elderly from active life promotes the well-being
of the aging person and serves society's need to make room for
the oncoming younger generation. Others have argued that con-
tinued activity, not disengagement, is what fosters optimum
adjustment and life satisfaction in old age. As in art, so in
the social science of gerontology, the issue remains unresolved.

The Gray Radicals

Most artists who have studied aging, like most social sci-
entists who have done so, regard disengagement and continued
middle-aged activities as comprising the whole range of possible
meaningful responses to the experience of old age. But there
is a different view sometimes reflected in artistic interpretation
which suggests that something other than either the activity
or the disengagement orientations is the appropriate response
to growing old. This might be called the radical approach to
aging. It advocates a politically activist role that goes beyond
the activism of conventional middle age into a civil disobedience
based on seeing through the conventional social illusions of youth
and middle age. A literary example of this view is given in
The Autobiography of Jane Pittman. The black woman whose
life story is told in that book accepted every racist evil that
came into her centenary life, until in her advanced old age
she at long last defied segregationist constraints, drank from
a "white" drinking fountain, and by that symbolic act enlarged
the scope of possibilities toward which her people could there-
after aspire. An artistic representation of this theme of old age
as a period of activist leadership is found in John Stuart Curry's
John Brown (pl. 23).

Sexuality in Old Age

In addition to the problem of disengagement versus con-
tinued activity as general life orientations, several specific di-

mensions of life-style among the elderly have been explored in art. One of these is sexuality in old age. Three possibilities have been extensively explored. First, old age has been represented as a time in which midlife sexual interests and activities continue essentially unchanged. Second, it has been depicted as a time in which those interests are extinguished and sexual activity is discontinued—old age as sexless. Finally, the later years have been shown as a time in which sexual interest and activity continues but with a different meaning than it has at earlier ages.

Advanced age as such does not cause loss of sexuality. There may be a decline in sexual activity and interest as individuals grow older, but there is no decade in life in which they are completely absent. Sexual activity may take place in advanced old age—as among Caucasian people of Russia. Known for their longevity and vigor at very advanced ages, many Caucasians report active sex life into their very late years. In a study of the Upper Skagit Indians of Western Washington, it was found that the elderly were open and responsive to affairs of the heart. Old people showed romantic interest in one another, wrote love letters, and sometimes changed spouses. Old age, when one's children were grown, was regarded as a suitable period of love affairs. Old lovers were not considered unusual. Although they may seem exotic to us, such practices can take place wherever the attitudes of society toward the expression of sexuality in old age are not too restrictive.

Artistic representation of sexuality in old age is not a story of decline or exclusion. Many images of the elderly in art affirm the continuation of fulfilling sexuality in late life. Some of these are artistic interpretations of biblical stories. The story of Lot and his daughters, for example, which affirms the continuing sensuality and physical potency of old age, has been repeatedly interpreted in painting (pl. 25). The story of Abraham, Sarah, and Hagar is an Old Testament story of continued normal sexuality in old age that is frequently interpreted in art. Abraham is usually shown as an aged man and Hagar either pregnant with or caring for their son, Ishmael. Sarah later bore Isaac and Ishmael was banished with his mother (pl. 26). This story, and the works which have been painted to express its meaning, also tell of negative aspects of sexuality—the arousal

of jealousies in the later years and the complications of love triangles. But these are not problems peculiar to old age— they are experiences which can occur at any time of adult life, including old age.

Another positive interpretation of sexuality in late life gives expression to the fulfillment to be found in a relationship in which passion has dimmed but intimate sharing of life and affection continue (pl. 24,79).

Religious Faith

Religion is another specific dimension of life in old age that artists have observed and interpreted with sensitivity. More often than not they have reflected the intuitive feeling of many people that devoutness increases during old age. The representation of the elderly in prayerful or devout postures and gestures is something which most people find very natural and acceptable.

Religious belief is not a simple unidimensional concept. It involves a number of different dimensions of possible awareness and growth. Only some of these are consistently represented in art as increasing with age. In general artists have not affirmed that the elderly experience an increase in such outward expressions of religious belief as participation in public worship, fasting, participation in sacraments, and the like. Similarly, there is little in the observation of old age in art to suggest a stronger adherence to official doctrines of one's particular religion or sect, nor increased factual information about the basic tenets and sacred writings of one's faith. On the other hand, religious feeling—the inward personal responses expressing our basic relationships to God and to other people—are often shown as heightened in old age.

Accepting Loss

A third specific dimension of old age that has been explored in art is the elderly person's capacity for adjustment to loss. The changes that occur in our lives during old age can

be traumatic and disorienting. To the extent that we experience significant loss in old age, we can come to feel that we no longer understand the world or our place in it. As a result we strive to gain a perspective on the losses which come with old age which allows us to explain their occurrence in human life and thereby make a satisfactory emotional adjustment to them. In this way the occurrence of loss often poses for the aging person a basic philosophical issue that is somewhat different from the acitivity/disengagement dilemma. Evelyn Whitehead has described this as the problem of examining one's basic understanding of the world so as to clarify whether the real nature of the world is characterized more by stability and permanence or by impermanence and change.

Safe Harbor

If our underlying belief about the world sees it as composed of stable and permanent "things" whose changes are only incidental, Whitehead suggests, we will envisage a good old age as arrival at a safe harbor in which we, like nature, are in a condition of relative stability and peace. People with this outlook tend to seek and to expect an old age that is protected from the vicissitudes of life and sudden reversals of fortune. From this perspective, the dramatic losses that characterize the aging experience are seen as unredeemable evils.

Pilgrim on the Way

A contrasting perspective is based on the belief that the world is inherently in process and change. According to this view, the relative stability of life in childhood and middle age is illusory—a failure to understand that in reality each human life must adapt to the unceasing process of change which is inherent in all things. From this point of view, a good old age consists in living more nearly in accord with the nature of reality. This means living a life of process and change. The successfully aging person, by this view, is not the person who

lives in an illusory temporary protection from the challenges of change and loss, but the pilgrim on the way. For the elderly person conceived as pilgrim on the way, the changes and reversals which can beset old age are seen not so much as losses as occasions for testing one's human spirit and as opportunities for spiritual growth. This view argues that old age forces on us a recognition of the inevitability of change and eventual nonexistence in all things—including our own existence as individuals. It is only with this recognition, it would be argued, that true inner composure and spiritual peace can be attained.

Both sides of this theme have been represented in paintings of the elderly. The imagery of the world and of good old age as safe harbor is found in Schjerfbeck, *At Home* (pl. 32) and in Eakins, *Chess Players* (pl. 83). The contrasting imagery of the pilgrim underlies the special poignancy of Ghirlandaio's *An Old Man and His Grandson* (pl. 65). This is expressed by the river in the background, the disease from which the man is suffering, and the fleeting nature of the moment which is shared by the man and boy. Other expressions of this theme are Manet's *The Old Musician* (pl. 33) and *An Old Man Holding a Pilgrim Bottle* from the Italian School (pl. 50).

Nearness of Death

The nearness of death is inevitable in old age. An old person may go through the death of a spouse, relatives, and friends. It becomes clear that life comes to an end. Munch forces us to recognize this by depicting a room where a group of relatives is gathered together at a deathbed (pl. 35). They express the anxiety, fear, and mourning of survivors. These feelings seldom preoccupy the dying person, who may give much of his attention to minimizing the hardships faced by those left behind. Käthe Kollwitz depicts the touch of death in a gloomy scene which conveys the feeling of fear or traumatic experience. However, emotional stability in death is more often the case among the elderly than is commonly assumed. Although elderly people do not look forward to the prospect of death, their most

frequently expressed attitude seems to be: "When death is ready for me, I will be ready for it." In general the elderly accept death more easily than younger people, who tend to see their own natural deaths as unthinkable.

3. The Wisdom of Old Age

Do We Grow Wise or Senile?

One of the more harmful myths about old age is that it brings mental decline. Many people suppose that a large percentage of elderly people have significant loss of mental abilities. Others exaggerate the importance of relatively insignificant mental changes, such as the commonly experienced weakening of short-term memory. Actually only a very small percentage—less than 5 percent—of people over sixty-five suffer any significant decline of mental competence. The outlook for mental agility and creativity in old age is far more optimistic than popular stereotypes would suggest. The study of old age through art reminds us of this, because in the history of art there are so many representations of the mental strengths that appear in late life. What has been shown in gerontology has often been represented in art; namely, that old age can bring various forms of growth in intellectual, moral, and religious understanding. Many elderly people, especially if they are intelligent, mentally

alive by temperament, and in good health, seize the opportunity for this kind of growth. As a result these people develop an enriching perspective on life in their late years—in short, a perspective of wisdom. Three specific sources of wisdom in old age have been noted by gerontologists and by artists. These are life review, integrative understanding, and universal perspective.

Looking Back: Life Review

One important mental activity characteristic of old age that has been frequently represented in art is reminiscence about the past. Many of the most engaging images of the elderly in art evoke an unmistakable sense of looking back, of thinking back over one's life in a mood of reverie and reminiscence (pl. 42, 43). This activity has been sensitively observed and recorded by visual and literary artists throughout history. Further understanding of it has been achieved by gerontologists in recent years. In his article *Life Review: An Interpretation of Reminiscence in the Elderly* (1961), Robert Butler has given this sort of reminiscence an appropriate label: life review. He believes that life review is a universal development in elderly persons, a looking-back process in which the content of one's life slowly unfolds and which is reflected in the familiar tendency of elderly people to reminisce about their past lives. Of course this kind of looking-back process occurs at all ages, at stopping points and summing-up intervals where we attempt to get perspective on where we have been and perhaps on where we are going. But the life review of old age is special, both in being more intensive and in being relatively final. For it is only in the life review of old age that we look over our whole lives—over the experience of having lived a whole human life—in an effort to arrive at a settled, final judgment about the ultimate meaning and value of life and the important experiences and relationships it contains.

Life Review in Your Dreams

The process need not occur in a highly systematic or visible way. It might occur through conscious direction and control, or

manifest itself in intermittent, unbidden memories which come randomly. It can take the form of recalling important or especially meaningful events from one's past life and considering them in relative isolation. At other times it consists in a rather orderly reconstructing of the main narrative threads of one's life story. In both forms, the process enables the aging person to evaluate past events, activities, successes, and failures in the context of his whole life. When it is successful, long-buried conflicts are sometimes reexamined and resolved and a sense of the meaningfulness and value of the unique individual life we have lived is achieved.

Heritage Is Sharing Your Story

An elderly person's telling the story of his past life can sometimes take the form of sharing that story with children and grandchildren. This kind of reminiscence, in addition to fostering other objectives of life review, can also give the aging person a strong sense of continuity with the future. For telling the story of the past can serve as a vehicle for passing on many of our basic values, beliefs, and traditions to the oncoming generation. Many elderly people report this achievement of continuity with the future to be a fundamental source of satisfaction in old age.

The life-review process, when it is shared by an aging person with family members or others, also has importance for those other persons. For in life review it is not only the aging person's own individual past that is recaptured, but the historical sources of our own existence—of our "roots" as well. We all have an abiding interest in and a certain strongly felt reverence for the sources of our existence and of the present time. This kind of feeling was especially strong in certain early cultures, which seem to have attributed almost a kind of priestly sacredness to the reminiscences of the elderly. The elderly were highly valued for their ability to retell the tribal origins, traditions, and myths. This seems to be part of what is reflected in the scene depicted by Blumenschein (pl. 44).

The Unexamined Life Is Not Worth Living

Much of the expressive strength of images of reminiscence in old age lies in our intuitive feeling for the importance of life review. After all, if it is true that "the unexamined life is not worth living," it seems to be at the end of life—when we have the experience and perspective of a whole human life to draw on, that its meanings and values can be most deeply and reliably understood. This was observed by Schopenhauer in his essay *The Ages of Life* (1904):

In our early days we fancy that the leading events in our life, and the persons who are going to play an important part in it, will make their entrance to the sound of drums and trumpets; but when, in old age, we look back, we find that they all came in quite quietly, slipped in, as it were, by the side door, almost unnoticed.

The most curious fact is that it is only towards the close of life that a man really recognizes and understands his own true self— the aims and objects he has followed in life, more especially the kind of relation in which he has stood to other people and to the world. It will often happen that as a result of this knowledge, a man will have to assign himself a lower place than he formerly thought was his due. But there are exceptions to the rule, and it will occasionally be the case that he will take a higher position than he had before.

The first forty years furnish the text of life, while the remaining thirty supply the commentary; without the commentary we are unable to understand the true sense and coherence of the text, together with the moral it contains and all the subtleties which it admits.

Right or Wrong—Does Life Review Give Answers?

A mood of quiet reverie and reminiscence associated with life review is what is most suggested by some images of the elderly face. Others express the dramatic confrontation with the important questions encountered in life review. In these faces, the urgency and weight of those questions has fully registered,

but no answers have yet been found. This sort of painful uncertainty or confusion about life's most basic aspects seems to be what is expressed, for example, by several of Rembrandt's best-known self-portraits (pl. 1, 2). These images have long been seen as expressions of the battering inflicted upon us by the aging process. But it is not primarily the accumulation of physical insults to the body that is most important here—though this is powerfully represented in these pictures. Rather it is the emergence in an aging man's eyes of a look of a profound confusion, expressing an inability any longer to understand the basic meaning and direction of life. This kind of confusion is a common occurrence in life review. For besides bringing clear understanding of issues of value and meaning in life, the process of life review can raise unanswerable dilemmas. This occurs when a person experiences what we might call "judgment reversal" as part of life review.

Mood of Confusion

Dostoyevsky explored the phenomenon of judgment reversal in life review, most notably in the character Velchaninov in *The Eternal Husband*.

Some of the facts he remembered had been so completely forgotten that it seemed to him a miracle that they could be recalled. . . . But the point was that all that was recalled came back now with a quite fresh, surprising and, till then, inconceivable point of view, and seemed as though someone were leading up to it on purpose. Why did some of the things he remembered strike him now as positive crimes? And it was not a question of the judgment of his mind only: . . . it reached the point of curses and almost of tears, inward tears.

Velchaninov's memory of an incident in which he had insulted a "harmless, bare-headed and absurd old clerk" involves just such a reversal of perspective:

And now when Velchaninov remembered how the poor old man had sobbed and hidden his face in his hands like a child, it suddenly

seemed to him as though he had never forgotten it. And, strange to say, it had all seemed to him very amusing at the time, especially some of the details, such as the way he had covered his face with his hands; but now it was quite the opposite.

"Now it was quite the opposite." There is a human dilemma implicit in these words—a dilemma which seems to be expressed in the look of painful bewilderment in so many of Rembrandt's late portraits. Which of Velchaninov's judgments is more nearly true to the remembered event as it actually was at the time it occurred: the judgment of the immediate situation or the retrospective judgment of life review? Was the remark to the clerk humorous, as it seemed at the time? Or cruel and self-aggrandizing, as it now seems in retrospect? Surely everyone is familiar with the sense of bafflement and uncertainty created by this kind of question. Sometimes this may concern relatively unimportant issues, but at others the same kind of uncertainty can affect our thinking and feeling about the most central decisions and actions of our lives. It is in these latter cases that the painful and deeply felt confusion registered in Rembrandt's self-portraits becomes a part of the experience of aging.

Punishment for the Past

Although life review can lead to conflict resolution and fulfillment in old age, there is no guarantee that it will. Positive outcomes are widely reported in literature and in geriatric research. But so are negative outcomes. A well-known literary example is a scene from Tolstoy's *Death of Ivan Ilych*. The hero of the story is ill and dying. As he reflects upon the meaninglessness of his death, what now hits him so forcefully is the meaninglessness of his *life*. He had lived a conventional kind of existence, having achieved the material and social successes expected of him. But on his deathbed, these so-called successes appear in a different light.

"What do I want?. . . . To live? How?. . . . Why, to live as I used to—well and pleasantly.". . . . And in imagination he began

to recall the best moments of his pleasant life. But strange to say none of those best moments of his pleasant life now seemed at all what they had then seemed. . . . And the further he departed from childhood and the nearer he came to the present the more worthless and doubtful were the joys. . . . "It is as if I had been going down-hill while I imagined I was going up. And that is really what it was. I was going up in public opinion, but to the same extent life was ebbing away from me. And now it is all done and there is only death. . . . Maybe I did not live as I ought to have done. But how could that be, when I did everything properly?". . . . And whenever the thought occurred to him, as it often did, that it all resulted from his not having lived as he ought to have done, he at once recalled the correctness of his whole life and dismissed so strange an idea.

This sense of things going irredeemably wrong seems to be expressed in several pictures by Kollwitz (pl. 3). One group of people who seem to be especially vulnerable to a sense of meaninglessness or regret in life review are those who throughout their lives have avoided the present and instead placed their hopes in the future. For these people there can be a sense of disillusionment as they discover that contrary to their expectations old age is not the bright tomorrow for which they have sacrificed throughout their lives. Another vulnerable group consists of individuals who have lived a pattern of inflicting harm on others.

Settling Differences: Integrative Understanding

For all its importance, life review is not the only form of cognitive growth in old age. According to psychologist Erik Erikson and other gerontologists, there is another mental strength which flourishes in old age and which corresponds closely to the traditional idea of wisdom. This is "integrative understanding," the ability to transcend the tensions between such conflicting basic opposites as love and strife, youth and age, male and female, freedom and restraint, life and death. At other stages of life we tend to experience these polarities as stressful con-

flicts between irreconcilable opposites. In old age we experience them instead as mutually reinforcing and enriching counterpoints of one another. We understand that the fundamental problems of human existence are resolved, not by the ascendancy of one member of a dialectical pair over the other, but through their natural and balanced interaction.

The Ox and The Ass

This ability to experience the underlying unity of conflicting opposites is central to the representation of St. Joseph and the Magi as old men in Nativity scenes (pl. 46). The Christ Child represents the reconciliation of the divine and the human. In his birth the idea of the absolute opposition of God and man, of the spiritual and the material, is overcome. Reconciliation of opposites is also the meaning of the ass and ox. These beasts were originally symbolic of the contending brothers of Egyptian religion, Seth and Osiris. Their presence at the Nativity scene signifies that in Christ all religious conflicts of the past can be reconciled. In the Virgin Mother also, contradictions are transcended: motherhood and virginity, humanity and divinity, earth and heaven. The entire scene, through the familial bond of newborn Child, adult Mother, and elderly Joseph, expresses the underlying unity of interest between the generations. In Joseph, the most human of the central triad of the Nativity, expression is given to the hope for religious insight into the ultimate harmony of all apparent opposition. For this insight is achieved, we now know through the findings of gerontology, primarily in that last stage of life—old age—in which Joseph is traditionally shown.

Harmony and Discord

Representation of the elderly person as a musician is another way in which this theme has been expressed in art, since the ability to make music is a symbol of the ability to harmonize conflicting and discordant notes of life. In Degas's *The Re-*

hearsal (pl. 47), for example, the seasoned virtuosity of the old violinist contrasts with the young girls' struggle with an as yet imperfect mastery of dance and of life.

An interesting version of the same theme is Rembrandt's *St. Paul* (pl. 48). The saint's struggle to integrate the polar opposites of experience is symbolized by the opposition of light and dark in his clothing, face, and background, so that the inner contradictions he strives to resolve are mirrored in his body and outer circumstances. The dynamic movement in the composition, the play of light and dark, and the saint's posture all indicate that we see him in a moment of creative tension. If insight and integration is the goal toward which he strives, it has nevertheless not yet been achieved. He seeks light and truth from the book at his side, but much darkness remains and continues to surround him—the outcome of this spiritual crisis is still undecided.

Rembrandt loved to create tensions between light and dark in his compositions to symbolize the struggle within the aging person between the light of understanding on the one hand and the darkness of ignorance and delusion on the other. He used the same method to create the drama of spiritual crisis in images of his own aging face.

Let a Thousand Flowers Bloom: Universal Perspective

One aspect of human life is that of spiritual pilgrimage, or progress toward moral and religious maturity. Nothing is more difficult to achieve in this process than the ability to judge other people from the standpoint of empathy for the common humanity we all share, rather than from the narrow standpoint of our own self, family, or social group. According to recent research in the psychology of moral development conducted by Lawrence Kohlberg, our ability to forego self-interested judgment for a more universalized, empathetic form of judgment tends to grow stronger in old age. The special affinity of the elderly for this kind of empathetic judgment is often expressed in images

of the father in the biblical story of the Prodigal Son. The forgiving father is invariably depicted as an old man of superior moral insight. In Van Baburen's version (pl. 49) of the theme, the ability to "universalize" judgment of others is beautifully expressed by the encircling line of the father's embrace, which seems to say: "nothing human is alien to me."

If the ability of empathetic moral judgment does exist, and if it is true that this ability tends to strengthen in old age, it would seem to follow that old age is a period of enormous social importance. The capacity to forego self-interest and affirm a standpoint of universal humanity would seem to be essential to our efforts to resolve the world's more urgent problems.

The Perception of Time

Besides the transformations of perspective and judgment involved in the experiences of life review, integrative understanding and universal moral perspective, late life also brings significant changes in the subjective experience of time. One of these changes is the experience of the passage of time as speeding up. Gerontologists have suggested that this change in our experience of time occurs because as we grow older we are more aware of the diminution of time left to us, and for that reason attach greater value to the time remaining in our lives. Whether this is the correct explanation or not, what is clear is that most elderly people experience time as quickening its tempo.

A contrasting alteration in the experience of time also occurs in late life. Many elderly people report an increased occurrence of those special experiences in which we seem to escape a sense of temporal passage altogether, finding in its place an experience of "timeless moments" which fall outside the realm of clock time. This is a state which poets, mystics, and philosophers have long admired as giving the best insights into the meaning of life of which we are capable. The rather complex changes in the importance and meaning of time in old age have been recorded in some of the more poignant images of aging. They seem to be summed up in a single image, for example, in the aged workman of Marcel Gromaire's *Old Flemish Reaper* (pl. 100).

Mental Challenge: Striving for Growth

The foregoing discussion should make it clear that there is more to mental development in old age than generalized decline. Nevertheless it would be a mistake to romanticize the mental powers of the elderly. It is not as if wisdom, insight, and understanding come to the aging person without effort, simply as a reward for having lived long. Instead, old age is, just as any other developmental stage, a time of mental challenge: we can, through discipline and effort, experience intellectual and emotional growth, or allow our mental and emotional potential to atrophy. This ambivalent situation is beautifully expressed in Rembrandt's studies of the human face, including many of his self-portraits (pl. 1). One side of his visibly aging face falls in shadow—representing a threat of intellectual decline and atrophy. The other side of his face is in full light—presenting the promise of continued intellectual and emotional life. The same theme of ambivalence is expressed in the seventeenth-century Italian painting *An Old Man Holding a Pilgrim Bottle* (pl. 50). This old man is crippled on one side—his crutch poignantly signifying the atrophy and decline that threatens—while on his other side a pilgrim-bottle and the globe he studies serve as emblems of his capacity for further exploration of life and growth. Themes of old age as a time of senility and general mental collapse are also well represented in art, as in any number of Goya's depictions of old age.

4. Generations

The Necessary Link between Generations

According to the Spanish philosopher Ortega y Gasset (1958), the relationship between generations is the single most important and controlling influence on our individual lives and on social change.

The most elementary fact of human life is that some persons die and others are born—that lives succeed each other. All human life, in its very essence, is boxed in between other lives which came before or which are to come after—it proceeds out of one life and goes into one which is to follow.

The generational nature of human life and the role of the elderly in passing on cultural forms to succeeding generations has been represented and interpreted in many paintings. Most of these say, in effect, that the passing of cultural forms from the elderly to the new generation is a matter of fundamental impor-

tance. And so it is, because the ability of individuals to achieve a sense of meaningfulness in life depends on what is passed on from earlier to younger generations. If what is good and valuable in the existing culture is successfully conveyed to the younger generation and what is irrelevant or harmful is allowed to fall to the side, civilization progresses. Otherwise, if this link between generations is not made, or conveys primarily what is useless or base from the existing culture, civilization stagnates or declines. This process of transmission of values, beliefs, and particular ways of living is of basic importance because the oncoming generation cannot create a meaningful way of life ex nihilo. We can imagine an extreme case in which the youthful generation is left to its own devices, without any inheritance of cultural forms to guide its form of life, such as is imagined in William Golding's *Lord of the Flies*. It seems likely that, as Golding argued, the ability of people to generate and carry on a civilized form of life under such conditions would be severely limited.

There are many great paintings which depict the elderly person as a cultural priest or official who confers status and legitimacy on the young (pl. 29,51). Some depict the elderly person in the role of helper or teacher (pl. 49,56). Other generational pictures stress the theme of generational passage through simple gestures of continuity (pl. 52,54).

Focusing on the Essential

There is much testimony in art, then, that the elderly are agents of continuity in society, through their role of passing on the culture to succeeding generations. But what specific content is passed on? After all, not *everything* is passed on. Is there any evidence that the elderly tend to select any special part of the culture for preservation? The answer seems to be that the aged pass on the *form* of the culture, or what could be called cultural forms, as distinct from specific *content* that those forms may take. This is suggested by the phenomenon of object diffusion characteristic of late mental style. According to the gerontologist David Guttman (1980), mental style in old age is

characterized by increased concern with objects and constructs that are relatively permanent.

The aged have learned that all things of seeming substance pass and fade: Their parents and the leaders of their youth are gone, peers are dying, the social mores change, and their bodies fail them. Though social objects desert them, they still search for that which will be constant and trustworthy. Since substance has failed, they seek the sustaining object in the insubstantial abstractions that cannot be lost.

Guttman goes on to explain that the insubstantial abstractions which the elderly come to regard as more trustworthy than the fleeting objects of earlier passions and interests are cultural ideals and values:

In traditional culture, the function of the aged is very clear: By turning abstract principles into collective representations and traditions, the aged create and preserve culture; and by doing so they play a great role in establishing the preconditions for a viable, decent social life. Small wonder then that across most of history, and in most human societies, they have been accorded much honor and much social power.

Our Need for Their Blessing: The Confirmational Role of the Elderly

This relative generality and abstractness of what the elderly tend to be interested in conveying to younger persons may help explain a theme frequently expressed in intergenerational paintings which depict the link between older and younger persons. That is the theme that elderly people sometimes exert far more influence and play a much more important role in a family or community than at first appears. Consider, for example, Degas's *Father Listening* (pl. 55). In viewing this picture our attention may first be drawn to the young man. Because he is playing, while the older man is only listening, we may feel that his role is seen by the artist as the more active and important role in the scene before us. But a more careful viewing indicates that this would be a mistaken reading of the picture.

The central position of the old man in the composition, and the dramatic highlighting of his head against the white background, indicate that his figure and activities are foremost in the artist's interest and statement. This is also borne out by the fact that the young man seems to be playing *for* the older man, his desire for the father's approval, and the effort he is making to secure it. What is important in the old man's role is his *being there* as an audience for the younger man's activity. By his presence he legitimizes the young man's activities and abilities. This important supportive role—providing an approving, responsive cultural environment in which adult activities go on—is seen also in Edelfeldt's *Washerwomen* (pl. 57). How different the psychological tone of both these pictures would be if the figures of the elderly people in them were replaced by young people. In each of them the elderly person adds legitimation of a cultural form that has importance for the life of younger adults, its authoritative confirmation. In various ways these elderly people preside or officiate over the passing of a cultural form vital to the members of the next generation. We can hardly underestimate the importance of this confirmational role of the elderly. For if there is anything which rivals the gift of life itself which the elderly have made to the next generation, it is the gift of a *way* of life, without which our lives can have significant content or meaning.

Seeing Beyond the Obvious

This confirmational role of the elderly is at the heart of the human meaning of the various scenes in which it is depicted. Nevertheless, in most of those paintings, it is neither the first nor most obvious thing to impress itself upon us. In this respect, such paintings accurately mirror the actual human situation of the elderly and our society's relationship to them—for we tend to overlook the background of cultural support which the endorsement of elderly people provides.

To conceive this more clearly, we might distinguish between explicit and tacit values. In every activity there are those elements which we directly attend to—which are in the fore-

ground of our attention and concern—and those which are taken for granted. For example, in playing a game we focus on the various moves, strategies, and tactics of winning, but we do not ordinarily focus on the basic rules. These are of fundamental importance and must be present for the various activities within the game to go forward toward its goal, but they are simply taken for granted. They are the background against which the other elements of the game are seen as meaningful and without which they would lack point.

This is a good analogy for understanding the supportive role of the elderly. In *Father Listening* the performance of the son is the explicit ongoing activity depicted. But the activity could not go forward in a meaningful way—at least not with the human meaning that it has in this picture—without the presence of the father and his approving response to it. And his listening goes far beyond *enjoying* the son's performance—that could be done by any audience. He imbues the son's performance with a deeper meaning by affirming it as an expression of fulfillment in his own life. This in turn provides a background against which the son's own life can acquire one important dimension of human value.

That You May Live Long and Prosper

The passage of culture from the elderly to the next generation is vital to society because it provides a background of cultural values needed for a meaningful and fulfilling life. But it is also important to the elderly themselves, because it provides an important social role through which they can achieve respect and status. Our tendency to abolish this role in modern societies is well documented in social science research. Its disappearance helps explain the negative images of aging which appear in the paintings of modern (roughly, industrial) times. The peculiar isolation of old age which seems to threaten the elderly in modern society, and which is shown in many modern paintings, is more than the isolation of ordinary boredom or loneliness. It reflects a feeling of desolation resulting from a thwarting of the activity and creative urge which is naturally

felt as the major developmental imperative of one's time of life. The activity of passing on cultural forms is a fundamental developmental need of the elderly. To frustrate its exercise and expression is deeply to disturb their well-being. This same theme of the special alienation which results from the disruption of normal communication between the elderly and other age groups has also received extensive treatment in twentieth-century literature, in such works as Robert Anderson's play, *I Never Sang for My Father,* Edna Ferber's short story, *Old Man Minick,* and John O'Hara's *Over the River and Through the Wood.*

The Elderly in the Community

The intergenerational theme often contributes heavily to the feeling of pictures representing people in social groups. The striking spirit and joy in group pictures by Bonnard (pl. 59), for example, seems to result partly from the easy and joyful relations between the elderly and younger members of the group— the integration of all the generations into a mood of shared activity and common feeling. In contrast, the cold stiffness conveyed by Bertalan Por's *Family* (pl. 60) seems attributable in part to the failure of its subjects to integrate the various age levels.

A major question about the elderly in contemporary American society is whether they are segregated or well-integrated in society. The results of research on this question are inconclusive and continue as a persistent controversy among social scientists. Some have argued that the aged are a subculture comparable to the subcultures of minority groups. But others have argued that the aged are not a minority group nor in any other way a separate cultural group.

A Question of Ethics:
Segregation of the Elderly

In addition to the empirical question of whether the aged are in fact a segregated social group, the problem of society's

relation to the elderly poses an equally important question of social ethics: *should* the elderly be a socially separate, non-integrated group? There are differences of opinion about this in social science and in art.

The mix of the empirical and ethical questions about age-integration creates a rather confusing array of possible philosophies of integration versus segregation of the elderly, each of which has been represented in art. The possible positions can be clearly differentiated from one another as follows:

The elderly *are* segregated and they *should* be	The elderly *are not* in fact segregated but they *should* be
The elderly *are* segregated and they *should not* be	The elderly *are not* in fact segregated and they *should not* be

Further, again both in art and social science, there are positions which address either the empirical or normative question without commenting on the other. Many pictures give simple matter-of-fact observations of well-integrated elderly (pl. 61-63). On the other hand, the image of *Jewish Old Men's Home in Amsterdam* (pl. 64), seems to accent the wrong of segregating the elderly.

Gerontologists have questioned the thesis that the elderly are more isolated from their younger family members in modern society than were the elderly of earlier societies. Gerontological research indicates that, contrary to a certain popular stereotype, the elderly in modern industrial societies maintain strong and fulfilling relationships with their own families and with other younger members of society. This does not diminish the importance of our attending to the theme of generational conflict and alienation in art. For a painting like *Old Man with Baton* (pl. 16) or a play such as Anderson's *I Never Sang for My Father* need not be taken as an accurate commentary on existing social conditions. It can be seen instead as warning us of very real traps and dead-ends to which life, and perhaps especially modern life, is vulnerable.

Giving and Receiving: Intergenerational Exchange

When the elderly pass on cultural meanings and related forms of support to the members of oncoming generations, it is not only the one-sided act of the old giving to the young. Many of the paintings which depict this kind of exchange also portray the generational link as being in the nature of an *exchange*. As the elderly man or woman transmits some human content to a younger person, he or she also derives some important enrichment, support, or understanding in return.

Grandparents

The grandparent role is usually depicted in art as a fulfilling and satisfying role for the elderly. This seems in fact to be the case. Elderly persons report a number of ways in which the role of grandparent has been a source of special meaning and satisfaction for them. For some, it offers an opportunity to play a new emotional role. Many individuals feel more successful and more adequate as grandparents than they did as parents. Many experience an emotional fulfillment as grandparents that eluded them as parents. As one man put it, "I can take the time to do things with my grandchildren that I never had time to do with my own children. I was too busy with my business to enjoy my kids, but it's different with my grandchildren. I have time to get to know them." Some people experience the grandparent role as a source of biological renewal. Many elderly people report that it is through their grandchildren that they "feel young again." A related and equally common experience is the achievement of a sense of social and cultural continuity with the future that a successful personal relationship with a grandchild seems to bring to many elderly persons. The experience reported is, "It's through these children that I see my life going on into the future." These and similar sources of satisfaction in grandparenthood are affirmed in images of the elderly such as Ghirlandaio's *An Old Man and His Grandson* (pl. 65).

The Ages of Life

The artists we have been discussing stress the interchange and relations of succession between individuals in different generations. Other artists view the succession of generations from the perspective of historical sequence, stressing the external view of a human life as moving through a schedule of status passages ending in old age and death.

Daumier has pronounced some particularly thoughtful and strong images of this kind, including *Third Class Carriage* (pl. 71) and *Waiting Room* (pl. 36). The succession of generations is related to the persistent idea that there are stages of life or ages of man. There has been great variation of opinion about how many distinct stages or phases are contained in a human life. The Hebrew Talmud differentiates some fourteen life stages; the Hindu *Laws of Manu* identifies four, Confucius six, Solon nine. Shakespeare's rendition of the subject may be the best known:

> All the world's a stage
> And all the men and women merely players.
> They have their exits and their entrances
> And one man in his time plays many parts
> His acts being seven ages.

What is common to these varying accounts, and the varying artistic interpretations of the same theme, is the conviction that life is developmental both within the individual's life and in society, having distinct stages and phases and requiring successful interchange between persons who are at different places in the life cycle.

Scapegoats for Fears of Aging

One of the most distinctive features of the relation between the elderly and members of other age groups in a society is the tendency for youth and middle age to fear and reject old age. Many younger people would banish old age from the scene

of human society if they could. This negative posture lies be-
hind much of the pressure to segregate and isolate the aged.
The aged of modern cultures are in this respect caught in a
vicious circle. First, we fail to provide for them the most natural
social function of cultural passage that is appropriate for their
age-stage in life. Stripped of this important source of usefulness
and esteem, they become little more than symbols of the nega-
tive corollaries of age: sickness, decline, and death. We then
reject them, because once seen in terms of this impoverished
conception of age they undermine our fantasies of eternal youth
and immortality. Thus they become scapegoats for our own deep
fears of aging and death. Once this outlook becomes sufficiently
pervasive, it encroaches on the self-image of the aged them-
selves, who in turn do not cultivate or manifest the virtues of
the wise elder so valued in earlier and simpler cultures. Instead,
overwhelmed by the cumulative power of images of the obso-
lescence of old age which they encounter around them, our re-
jected elderly manifest such emptiness and withdrawal that they
produce further rejection from the rest of society.

Dependency

An issue concerning the relation of the elderly to other
generations which cannot be avoided in modern industrial soci-
eties is the problem of dependency. The combination of tech-
nological obsolescence of learned work-skills and a social stereo-
type of the elderly as being over the hill and generally without
work-related ability has produced a great deal of emotional and
economic dependency among the elderly in many modern soci-
eties. Thus in the United States it is estimated that nearly half of
those persons over sixty-five live at or below the government-
established poverty line. The United States is not unique in this
respect. In fact poverty in old age has been a problem in many
societies, and artists have often recorded the consequences of
this fact (pl. 64,72,73).

5. Old Age in Myths

Mythical Images of Old Age

Numerous common beliefs about old age have such strong and persistent influence that they may be considered myths. Mythical beliefs about old age live both in popular stereotypes and in the long tradition of ancient myth. Both kinds are sometimes negative and demeaning, sometimes positive and supportive. They live not only in people's minds, conversations, and actions but in magazines, newspapers, retirement brochures, entertainment media, literature, and art.

What we are referring to as "myths" of old age do not usually influence us in a logical way. The set of ideas contained in a myth, for example, is almost always directly contradicted by those of another myth; and yet each of these may be to some degree embraced by the same person. The kindly and nurturing old woman of the grandmother's house myth, to be described below, is contradicted by the image of the old woman as witch; the myth of sexlessness is contradicted by the

myth of the dirty old man or aged satyr, and so forth. For every myth that paints a rosy picture of old age, as many others create anxiety about aging and fear of the later years.

Besides being contradictory of each other, myths also tend to be distortions of reality, in the sense that they call attention to and make larger than life some aspects of aging to the exclusion of others.

With the shortcomings of logical incoherence and only partial truth, why do myths have such a persistent role in shaping our experience of aging? The answer is that they enable us to give expression to strong emotion about human aging which we find impossible to express adequately without them. There is much about old age that evokes very deep and urgent responses in us, and which we find impossible to articulate fully in statements and propositions of ordinary language. Myths of aging are patterns of feelings, attitudes, concepts, beliefs, and perceptions which capture and give expression to some of these kinds of responses. For example, the myth of grandmother's house gives us a way to express our deeply felt hope that life in solitary old age can be rich and humanly fulfilling. Thus, while myths may be only partially true of the real world, they give us the necessary starting place in our effort to come to terms with our own inevitable aging experience and with the existence of the elderly people around us.

Popular Beliefs

One of the more powerful and captivating of the mundane myths of aging is the myth of *Old Mother*. This is the image of the elderly woman perceived as the Universal Mother—serene, respectable, possessing much wisdom and human warmth. The old mother is a woman who is aged, gray-haired, with features chiselled by maternal sorrows, sacrifices, and countless tears. It persists stubbornly both in art and in contemporary stereotypes of the older woman. It finds expression in songs, literature, and media. The best-known portraits of the mothers of artists draw on this myth (pl. 74-78). These portraits are usually painted by artists who have arrived at middle age and are at the height

of their creative ability. Since this timing for the execution of an artist's best portrait of his mother seems to be a pattern in the history of art, the thought suggests itself that the theme is one that is so dear to artists that they portray it when their artistic powers are most mature.

The myth of *growing old together* denotes old age as the period of life when a married couple has time to enjoy each other and each other's company. Free from the duties of child care and work, the elderly couple can share mutual interests and the pleasant routines of daily life. They are portrayed as going places together or as exchanging a variety of daily services such as meals, fixing objects in the household which satisfy everyday needs, or simply sitting together and quietly enjoying each other's company (pl. 79). This image, while containing much truth, tends to mask the common problems of widowhood in old age, such as the loss of a variety of support services and of the companionship of a spouse. It also can distract us from the obligation to offer companionship and support to solitary elderly people.

A common image of an elderly person's living context is that of the old-style home and household filled with down-to-earth warmth and nurturance. There is a nostalgic picture of the well-kept house with neat and cozy interiors and traditional furnishings, happily humming with hand-done domestic work (pl. 80, 86). This myth draws heavily on romantic nostalgia about the daily round of life in past times. The myth of *grandmother's house* casts a friendly, positive light on the elderly. But it also tempts us to gloss over or ignore their problems. These include housing problems experienced by the aged in urban residential environments and in nursing homes.

The myth of the *selfless elderly* is based on the belief that old people *should* be selfless, particularly toward their children and grandchildren. They tend to be seen as someone who can provide refuge from problems for their children, give financial support, entertain and instruct grandchildren, or watch a baby. The elderly are expected to practice child-oriented altruism— to live for their children. Grandparents must always be smiling, be ready with a comforting word, give a soothing hug to a crying child. It is presumed that their houses be open and ready at

all times to receive unhappy children. Elderly widows and wid-
owers are implicitly expected not to remarry because the new
spouse would intrude in the idyllic circle of the family and steal
attention (and inheritance) from children and grandchildren. The
myth of altruism mimimizes or overlooks old people's need for
their own interests, privacy, and independence.

The myth of old age as *life without problems* portrays
the late years as a generally peaceful period happily free of
troubles. In the imagery of this myth, the elderly are free from
the daily pressures of work and free to enjoy the simple pleasures
of life. The old person may be busy and highly involved in
daily pursuits, although these may appear to be trivial. Crafts,
hobbylike activities, or playing games may be pictured, as well
as a variety of projects of a recreational or quasi-work nature
(pl. 83-86). Grandmother bakes pies and cookies, hands out
recipes, knits or crochets. Grandfather sits in the rocker, reads,
repairs gadgets for grandmother, engages in gardening, builds
a birdhouse, or walks the dog. Both go to church and have
problem-free visits from children and grandchildren during the
holidays or family events.

The myth of old age as the "harvest" or "golden" years
presents a special fulfillment of life as the fruit of old age
and of life's work well done. In old age we can at last rest
on our laurels, whether those have been earned in a professional
field, in attaining wealth and material goods, or raising a family.
Aged persons are thought to have gained a greater degree of
control over their lives and to have won financial independence.
We may see the elderly retired person as using previous occu-
pational skills in some enjoyable related activity—a retired
teacher reaps inner rewards by volunteering as a counsellor
to troubled teenagers. On the other side of the myth of the
golden years we find the anxiety that often enters a person's
life when separated from the familiar routines of work, living
on substantially lower income, isolation from the social inter-
action of the workplace, and loss of the status given by work.

When younger people observe the behavior of elderly peo-
ple, they may conclude that *elderly people become like chil-
dren again*. Indeed, old people sometimes do seem childlike.
But this is not the same as being childish. When old people

act or think like children, it is not childish, but expresses joy, playfulness, wonder, and freedom of spirit (pl. 93). These attitudes may have been abandoned in middle age because of duties and responsibilities. Many old people can look at things fresh again with the inexperienced eye of the child, as if they were seeing them for the first time. In many cases the thinking and outlook of an aging person regains the qualities of creativity. The creative mind seldom accepts reality as it is presented, but searches for a novel, unobvious perspective. Creative people may not always make great contributions, yet they are continually sifting new information and remolding it into alternative models. There is an attraction or kinship between the creativity of old age and of childhood that beautifully completes the life cycle. Old people and children may need one another not only as grandparents and grandchildren but as members of different generations who have a similar mental outlook.

Considering the important role sexuality plays throughout life, it is unfortunate that many common misconceptions create sexual problems for older people. There is a widespread belief that older people are without sexual interest or feeling (pl. 94-96). Especially in the area of sex, older people are deprived of satisfactions by prejudices and stereotypes of aging which have created a *myth of sexlessness* in old age. Unfortunately these are often as ingrained in the beliefs of the aged as in the minds of the young. The economic system that uses youth and young images to sell products further limits the idea of life satisfaction through sex from old age. Some people even see romantic involvement and sex among older persons as objectionable.

The elderly are often believed to be *unproductive*. In fact, however, most elderly people continue to be productive in the world of work in a large variety of ways. This often includes active full-time employment. When elderly people do cease to work regularly, it is often because of socially imposed restrictions such as mandatory retirement or to disability and disease rather than because of the aging process per se. There are numerous artistic studies observing and interpreting the elderly person at work in almost every conceivable kind of trade and occupation (pl. 10, 11, 12, 22, 40, 63). Very few of these suggest obsolescence or inability to work productively; just the op-

posite message is the almost universal rule. In addition to con-
tinued involvement in ordinary work, older people also sometimes
excel in creative work. Substantial numbers of people experience
highly creative and productive years in old age.

The Elderly in Ancient Myths

It is well known that the ancient myths still manifest their
residual presence in the mental world of modern man. In many
parts of the ancient world geographical and geological phe-
nomena were interpreted as manifestations of the divine. A hill,
spring, or stone could become sacred, as the river Styx did.
The Styx was the river over which Charon, the old ferryman,
rowed the dead into the Underworld (pl. 103). Astronomy was
a rich source for mythology. In ancient Egypt, the sun at noon
was Re or Ra, the vigorous young god of Heliopolis; by eve-
ning, the sun became an old man, Atum. In Greek and Roman
mythology the planets were associated with gods and goddesses.
Saturn was associated with Cronus or Time—the aged ruler of
the world (pl. 99, 101, 102). The societal myths provided rules
and acceptable norms for living. They explicated mores and
gave foundations for human interaction. In the myth of the old
river god, Peneus, it is argued that chastity is to be valued
over love. Peneus preserved the virginity of his daughter Daphne,
who was pursued by Apollo, by changing her into a laurel
tree (pl. 104). In the legend of the Satyr and the wayfarer,
the elderly Satyr teaches us how to behave in a trustworthy
manner (pl. 105). In the tale of Philemon and Baucis, we are
told that those who are kind and merciful will be rewarded
(pl. 107). The myths about heroes whose feats were beyond
the ability of ordinary men dramatized what was possible and
acceptable in society. Some mythic heroes were elderly. The
aged hero is known for wisdom and prophetic foresight (pl. 108).
Witch lore is another area in which old myths survive (p. 109,
110).

Many past and contemporary ideas related to old age are
anchored in ancient myths. The essential elements of the old
Hebrew myths and the Christian myths still remain a rich source

of ideas and attitudes about old age. The Old Testament Yahweh and the Christian God is in Judeo-Christian belief God the Father. He is the Ancient of Days, and is usually depicted as an aged man (pl. 97-98).

Some myths about aging are found primarily in legends or folktales. They reflect simple social situations, describe ordinary fears and desires, present instructive incidents and display facile symbolism. This kind of myth is found, for example, in the folktale of Rip Van Winkle who after years of sleep woke up in a greatly changed world (pl. 111). Several versions of this story have appeared in various parts of the world. In a Scandinavian version two sisters, a boy and a girl, took a rowboat to an island, where they slept on roses until old age. The symbolism of the tale is simple—a wasted life. The lesson is clear and ingenious—we should strive for mental and spiritual growth and live life to the fullest.

There is a belief, as old as the ancient myths, that old people can foresee and predict the future. According to this idea, old people are adept at fortune-telling and palmistry (pl. 112). Another traditional belief is that elderly clowns have special powers of insight into the secrets of the inner soul (pl. 113).

PART II: THE PLATES

The heads of strong old age are beautiful
Beyond all grace of youth. They have strange quiet,
Integrity, health, soundness to the full
They've dealt with life and been tempered by it.

Robinson Jeffers, *Promise of Peace*

6. Old Age in Art

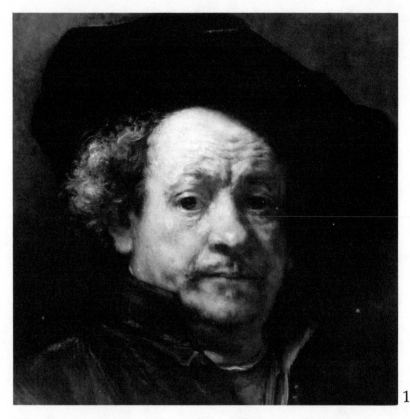

1

How Aging Artists See Themselves

Rembrandt's self-portraits (1 and 2) are the most universally known and admired images of the aging face. They have an unusually disturbing quality because they not only register the effects of the aging process but look out at the viewer, urgently seeking—even demanding—some answer to the questions that have been raised in the artist's confrontation with the human experience of aging. What values and beliefs can we defend, he seems to ask, that will enable the aging person to surmount the challenges posed by the prospect of growing old? Is human life meaningful and good, if its unavoidable terms are that old age follows upon youth? The intimation of these basic questions distinguishes Rembrandt's self-portraits from other images of human aging and helps to account for their exceptional power.

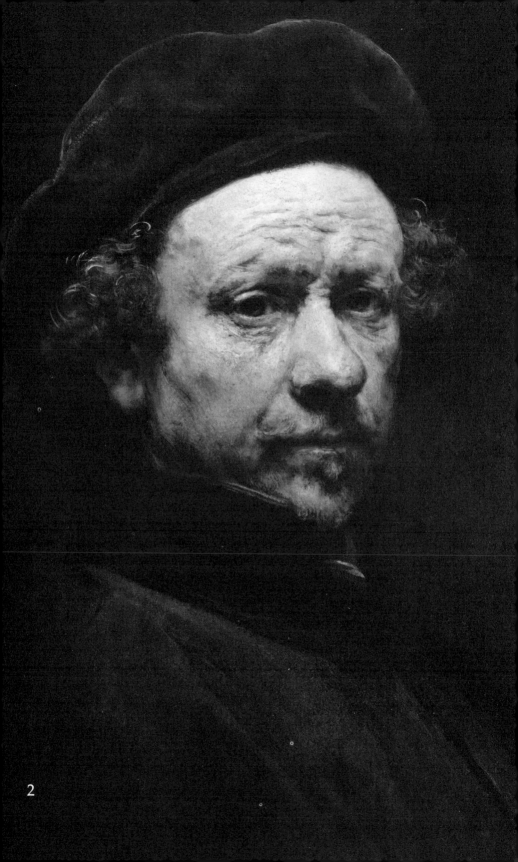

2

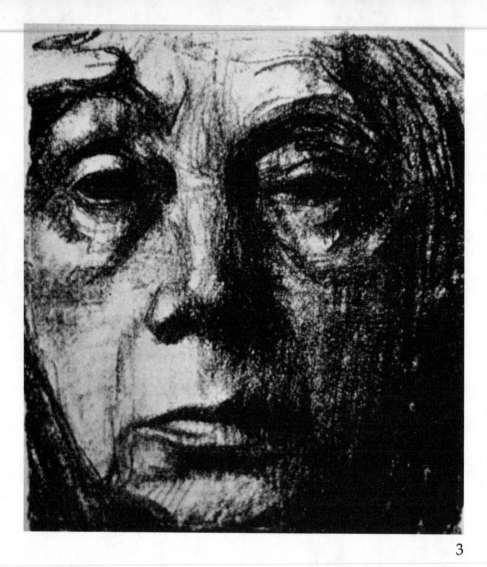

3

The questioning, troubled face of Kollwitz's self-portrait (3) indicates that old age is a time of far-reaching changes in our lives. Contrary to what is often assumed, old age is not a period of uneventful quietude. It is perhaps the most turbulent period of life, filled with many changes of great importance. These include alterations of physical appearance, an increased danger of illness, the loss of friends and loved ones through death, and the nearer approach of one's own death. These changes, and the weight of their cumulative effect, are poignantly reflected in Käthe Kollwitz's face. But we can also see great determination and intensity of emotion in her beautifully aged features.

Leonardo's face (4) shows us a man at peace with the world
and himself. Leonardo advises us to live constantly in the pres-
ent. In his notes he writes "In rivers, the water you touch is
the last that has passed and the first of that which comes; so
with the time present. The future is related to the past and
present, youth to old age and life to death in the rhythm in-
herent in nature. The spirit imprisoned in the life of the human
body continually desires to return to its original source."

4

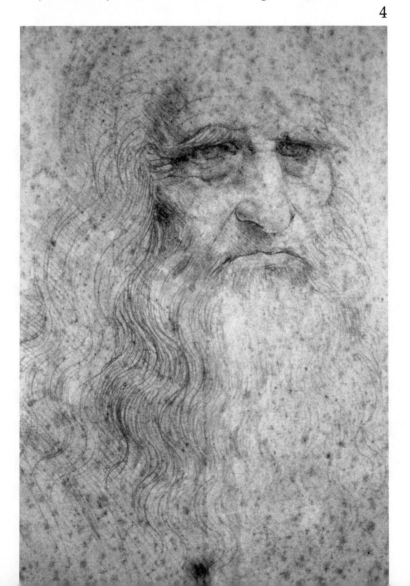

Good and Bad Aging

The late years may bring harmony and inner peace for many individuals for the first time in their lives. But some are bitter and angry about old age. The ambivalence about aging has been recognized and recorded in art.

Massys's picture (5) shows the elderly St. Jerome with body and spirit still in vital strength, studying the scriptures. Romerswaele (6) gives a relatively repelling interpretation of the same theme.

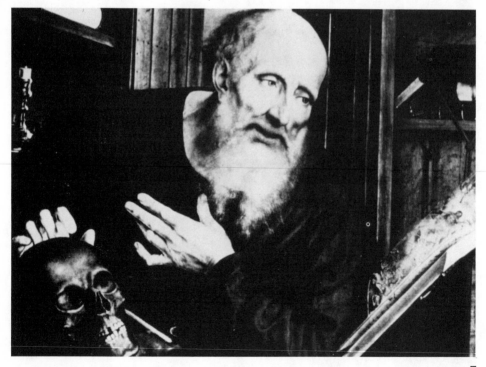

5

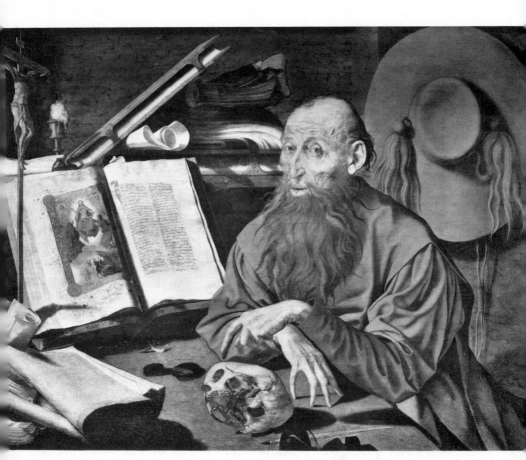

6

Blindfolded Society

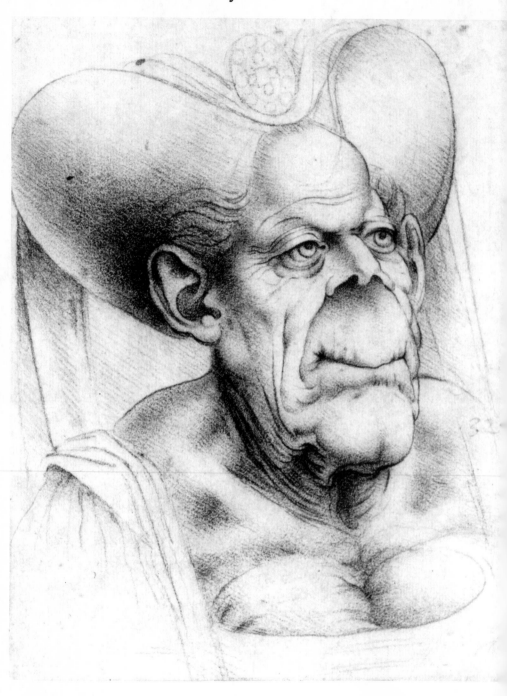

The negative images of aging presented here express our fears of aging and our tendency to focus on the negative features of aging rather than its visually attractive qualities. Albright's picture (8) is a nightmarish illustration of our fears that old age is without dignity and fulfillment. Leonardo's grotesque drawing (7) demonstrates that the elderly tend to see themselves as the other people see the aged persons—not the fulfillment of natural human development but a caricature of the younger years of life. Goya (9) shows us a gloomy scene in dark colors of how our distorted attitudes can create misery, suffering, and poverty in the lives of the elderly and finally turn against ourselves in our old age—cruel, evil and terrifying as the expressions of the old men in the picture.

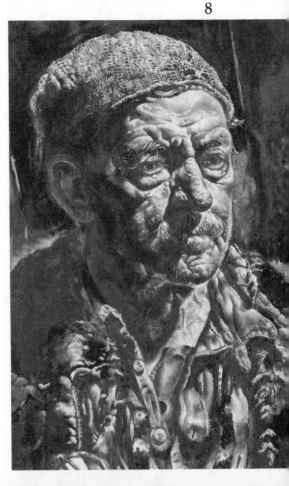

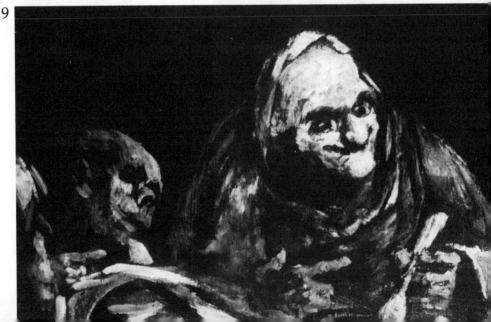

10

7. Ways of Growing Old

Staying Active

The old market woman (10) portrayed 2000 years ago represents many women who carry on their domestic or other work in advanced age.

Craftsmanship such as that of the blacksmith, built on a variety of skills and practical knowledge, has always been learned

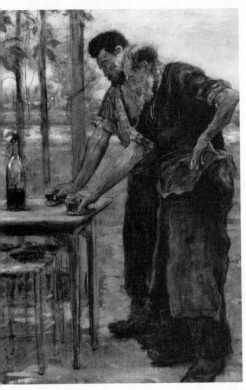

naturally in a working apprenticeship with an experienced master. The old blacksmith in Rafaelli's painting (11) has not retired but teaches his skills and methods to a younger one who learns by doing—even his way of holding the glass seems to be in imitation of the older man.

Daumier depicts a scene from a courtroom where an elderly lawyer defends his youthful client (12). In fact, the artist is portraying another artist. The advocate's performance is refined to almost cynical perfection. He even has managed to shed tears as he gestures and speaks with great eloquence. His expertise and skill are products of lifelong practice of his profession. For various reasons many people simply do not retire. This may or may not be a good thing since continued work into old age can deprive people of a well-earned opportunity to enjoy activities other than work.

11

12

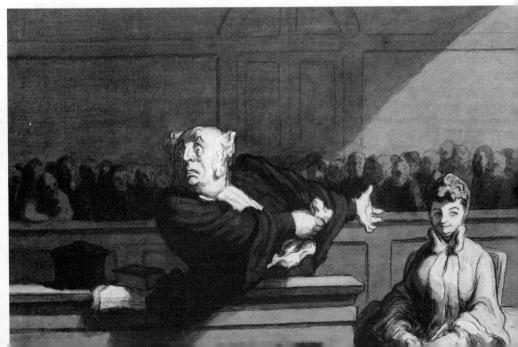

Disengagement

The state of mind which gerontologists have called "detached concern" is well expressed by the elderly woman depicted here by Sargent (13). The quality of her interest in the painting project before her is different from that of either the painter or the younger woman at the left. She is interested in the project and gives it her attention, but in a mood of disengaged objectivity. In contrast to the other observer, she exudes no bodily expression of involvement in the actual work—her body is withheld from such expression by the artist through its almost complete mergence with the background. The painter, her face left sketchy, conveys an effort to create through deliberate control of the artist's media and tools. The old woman's delicate, refined features portray a stage of personality development characteristic of the late years. Instead of approaching life as a thing to be controlled, she shows an openness to experience which allows it to unfold before the quiet gaze of a receptive mind.

They said, "You have a blue Guitar,
You do not play things as they are."
The man replied, "Things as they are
Are changed upon the blue guitar."
Wallace Stevens

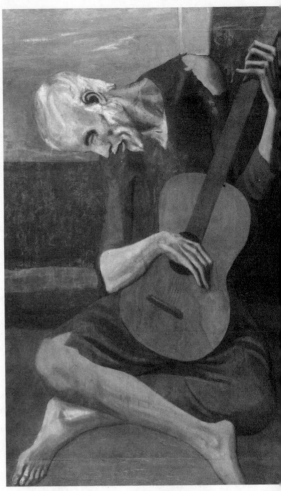

14

The lowered head and expression of melancholy in the face
of the old musician by Picasso (14) convey resignation and de-
tachment from the world. He does not play for any specific au-
dience, but expresses his inner self, staying within the private
world which his music creates around him.

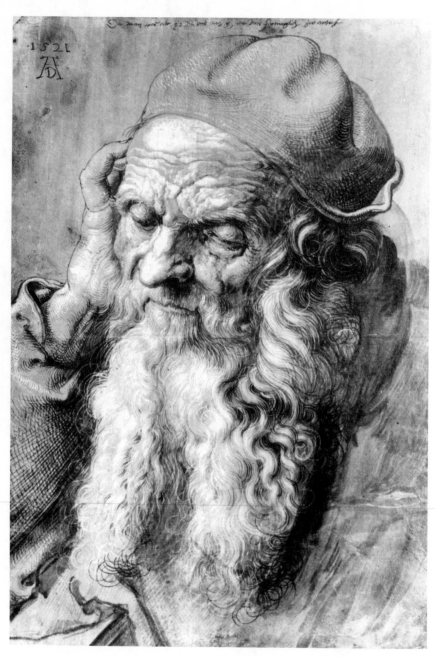

15

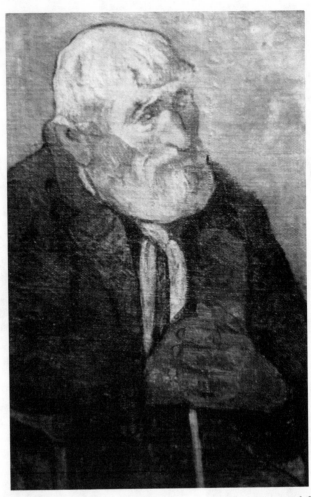

16

Physically in seclusion but still mentally active, Dürer's *St. Jerome* (15) studies the scriptures. This finely detailed study is an exceptionally careful analysis of the characteristics and beauty of the aging face. The pose and facial expression of the old man in Gauguin's picture (16) express loneliness and painful isolation. Both men are shown in relative disengagement, but the first with positive, the second with negative, overtones.

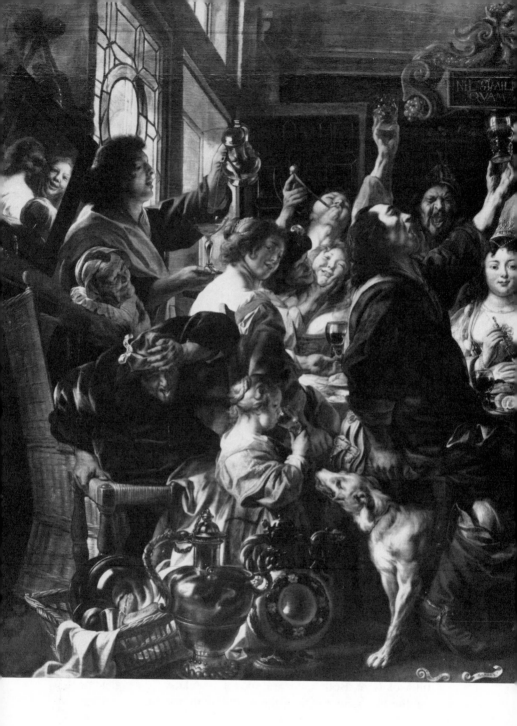

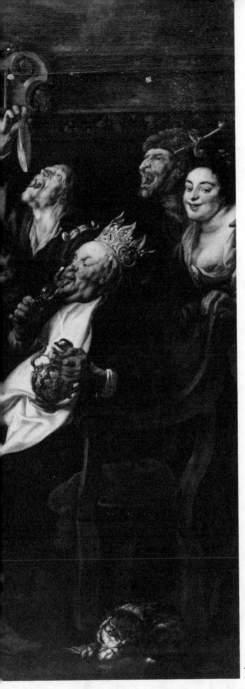

17

8. Hazards and Blessings of Being Active

The Old Fool

The Bean Feast was a festive annual occasion when an ordinary man was elected the king of the feast and treated accordingly. Surrounded by the merry crowd, the old man indulges in food and drink. The scene by Jordaens (17) seems to convey the message that persisting for too long in the activities of youth and midlife is to make an old fool of oneself.

18 a

18 b

Normlessness: Who Cares?

Normlessness, the elderly person's reduced responsiveness to conventional social norms, often is depicted in art. This antique Greek and Roman art work (18a,b) shows the uninhibited expression of anger and sexuality which can occur when internal restraints are relaxed in old age.

Old Age Can Say "Yes" to Pleasure

In Nahl's painting, Saturday night (19) has brought some miners together in a cottage to rest, have supper, and to discuss the day's work. There is a seriousness in the men weighing gold which contrasts with the levity of the old miner who relaxes with a bottle of wine. In his case concern for gold has eased and a rather carefree enjoyment of the innocent pleasures asserts itself in its place.

19

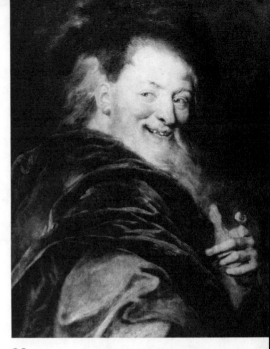

20

Coypel's painting (20) portrays the Greek philosopher Democritus, known as the laughing philosopher because he taught that pleasure is the thing to be valued in life. He also taught that true pleasure is most likely to occur in old age when long experience of life has taught us how to acquire it. Democritus still reminds us, through this image of a happy elderly gentleman, that old age can be a time of continuing deep enjoyment of the pleasures of life.

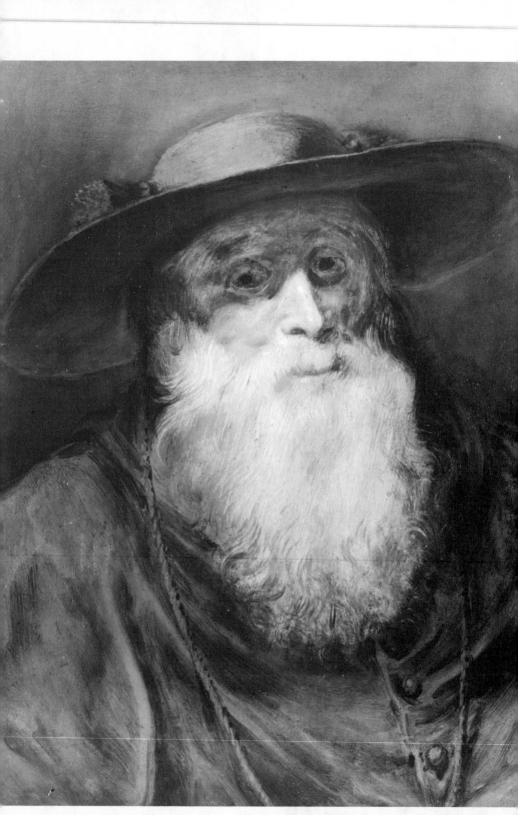

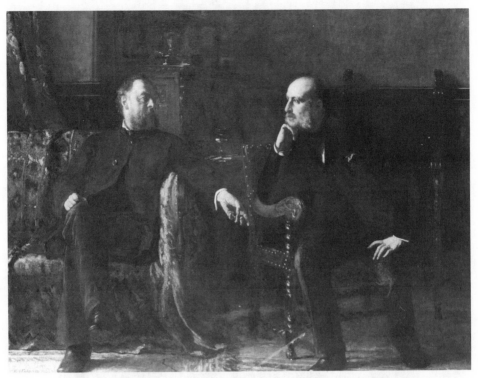

Social Influence and Power

The elderly person in positions of public office and power is a frequent theme in art. Many artists have expressed the philosophy of Plato that positions of social influence ought to be held primarily by elderly statesmen. An example of this theme is found in Johnson's *The Funding Bill* (22), which presents two such seniors conferring. In another example, Rubens portrays an old cardinal whose vestments dramatize his status as a ranking prelate (21).

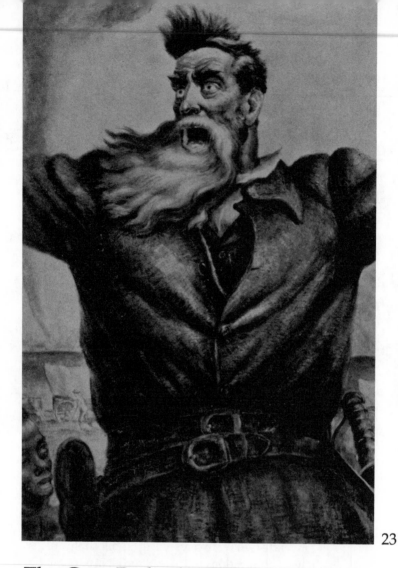

23

The Gray Radicals

Old age can be a period of activist leadership. The late years of the American radical and abolitionist John Brown is a case in point. His old age was a period of exceptional determination and enthusiasm for the abolitionist cause. John Brown became known when he planned to liberate the slaves through armed intervention. His attempts failed and he was hanged at Charles Town in 1859. His dignified conduct and the sincerity of his calm defense during the trial won him sympathy and led him to be regarded as a martyr. In Curry's portrait, his towering figure dwarfs both the tornado and the landscape in the background (23).

Sexuality in Old Age

Loving, caring, and togetherness fills the quiet embrace of the two elderly people in Dressler's picture (24). The barren trees outside and the cross in the windowframe speak of passing time, but the checkerboard floor asserts that the game of love is still going on.

24

25

The elderly couple in Daumier's *Always Joyful* (25) do not embrace, but there is nevertheless a visible bond of affection and natural enjoyment between them. While some elderly couples experience increasing conflict in their relationship, Daumier's image reminds us that we can develop an increasing sensitivity and skill in living together that results in a more enjoyable and rewarding relationship as the years pass.

Maes depicts Abraham casting out Hagar and their son Ishmael (26). Hagar, barefoot, is provided with a pilgrim-bottle and a few belongings. Ishmael seems to be better equipped for his quest, with his bow and arrows, and calling for his dog to accompany him. Hagar turns from Abraham in sadness and despair. The scene reflects the possible problematic consequences of sexuality in old age, as may hold true at other stages of adulthood.

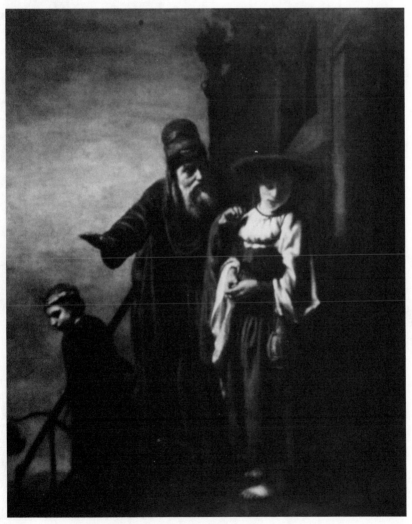

In Jan Massys's allegory (27) we see elderly Lot leaning on a tree. He is drunk from the wine his daughter offers him. Another daughter, half nude, tries to seduce him. In the background the cities of Sodom and Gomorrah, places of lewdness and corruption, burn in the sky. The allegory suggests that lust and greed can still seduce us even if we seemingly have outgrown their temptation in our later years.

27

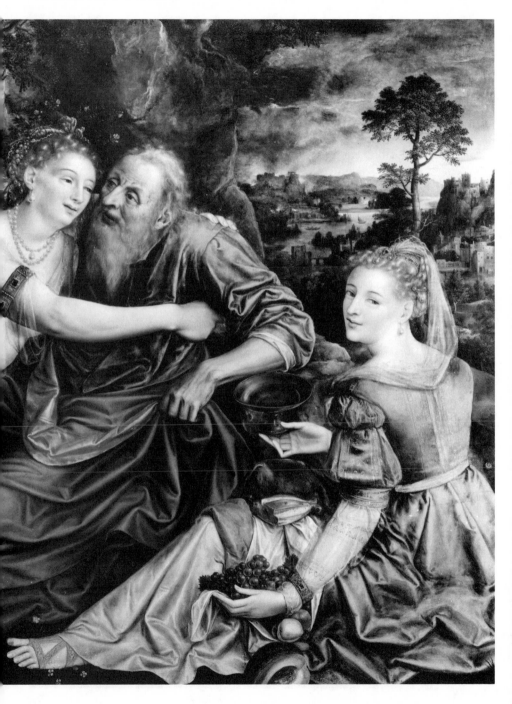

Religious Faith

In art, the devoutness of older persons is often depicted in its ritualistic forms. The elderly are shown, for example, with hands crossed in prayer, as in Rembrandt's painting (28). Votive scenes may show an elderly person worshipping the Holy Virgin. An elderly person may be shown in the act of performing a religious rite, as in Vouet's *Presentation in the Temple* (29). Or an elderly person may be shown reading from the Bible, perhaps to a young person, as the grandmother in Tasseart's drawing (30). This picture refers to the old custom of the daily Bible reading for instructional and devotional purposes within the family, a privilege and responsibility often reserved for the eldest member.

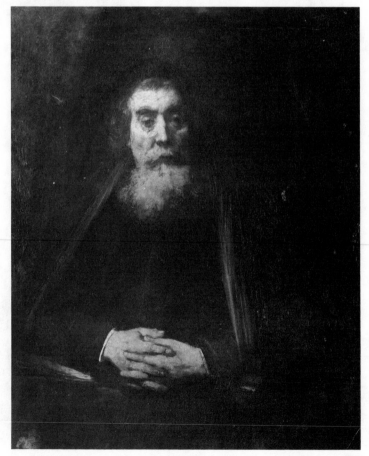

28

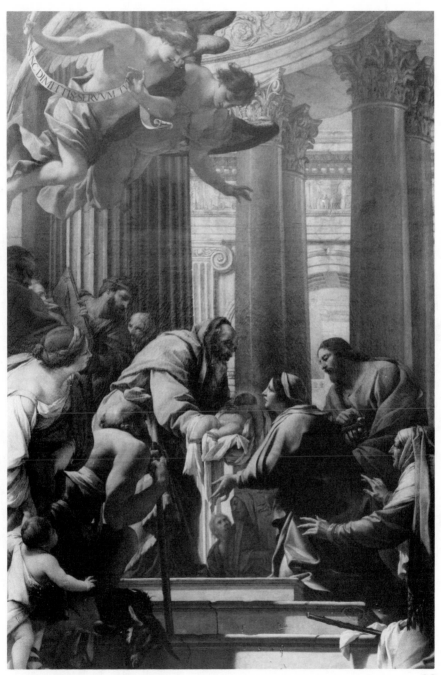

29

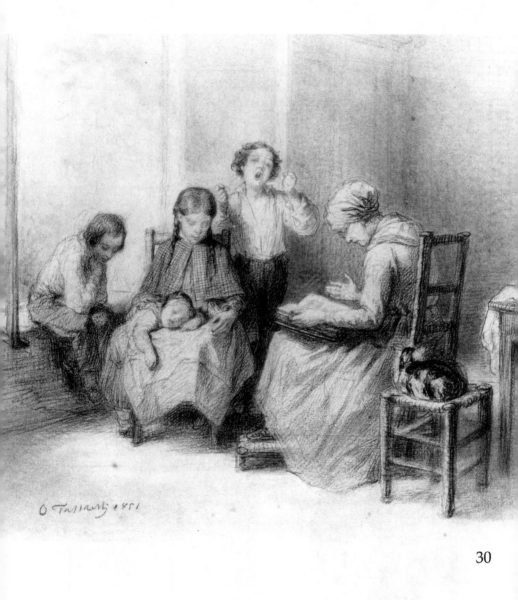

O Tassaert 1851

Accepting Loss

Old age, inevitably, is a time of loss. Although we may experience loss at any time of life, the losses in the late years are more frequent and less likely to be replaced than those which occur earlier. Many of the losses of the elderly, such as death of a spouse or friends, loss of income, or work activity are experienced as undesirable and depressing. But there can be a brighter side to many of these crises. Many younger persons do not understand that a loss for the elderly person may mean withdrawing from the stress of active and ambitious life or disengaging from the struggle for perfection, fame, and profit. Many elderly people seem to welcome the enjoyment of simple pleasures, peace, serenity, and quietness. Such individuals may see themselves and life more clearly and simply because they are finally free of the passions and striving of earlier years. Greater understanding of the world and of himself often strengthens an elderly person's ability to adjust to and accept the losses which occur in old age.

Safe Harbor

In Helene Schjerfbeck's painting *At Home*, an elderly woman sews in a cozy armchair. The peaceful, warm atmosphere gives a feeling of a safe harbor she has reached in her late years (32).

33

Pilgrim on the Way

The musician in Manet's painting (33) may have experienced the loss of everything we ordinarily think of as lasting. He many have lost his family, job, and home. Now, in his late years, life has nothing but the challenges of change to offer to him. As he can create harmony from the changing, fleeting notes of his violin, so he can create an inner harmony from the shifting exigencies of life.

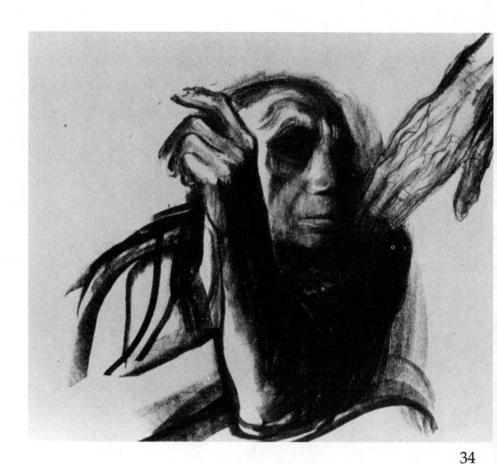

34

Nearness of Death

If at seventy I still plant trees,
Lookers-on do not laugh at my folly.
It is true of course that no one lives forever;
But nothing is gained by knowing so in advance.

Yuan Mei *On Aging*

Käthe Kollwitz's *The Hand of Death* presents an old woman touched by a visitor who beckons her to come along (34). Pathetically, the old woman raises her hand in a futile gesture of resistance. Kollwitz conveys a feeling that the visitor is familiar to the old woman. She has seen Death take friends and relatives and now, in spite of her reluctance, it is her turn to follow.

Munch shows a group of mourning people in his picture *The Death Chamber* (35). They cling to each other to seek consolation in time of grief. The deceased may have meant different things to each mourner but their poses express a similar intensity of grief. Munch uses strong dark and light contrasts to transmit the stark inevitability of death and grief. The mourner at the door is about to leave, indicating the equally inevitable return to the daily routines of life.

35

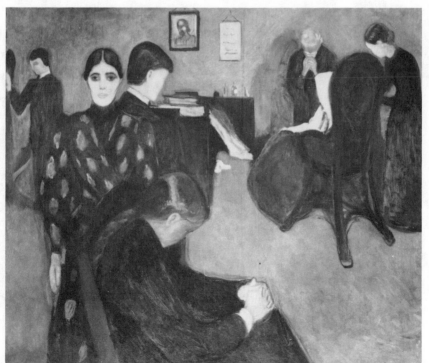

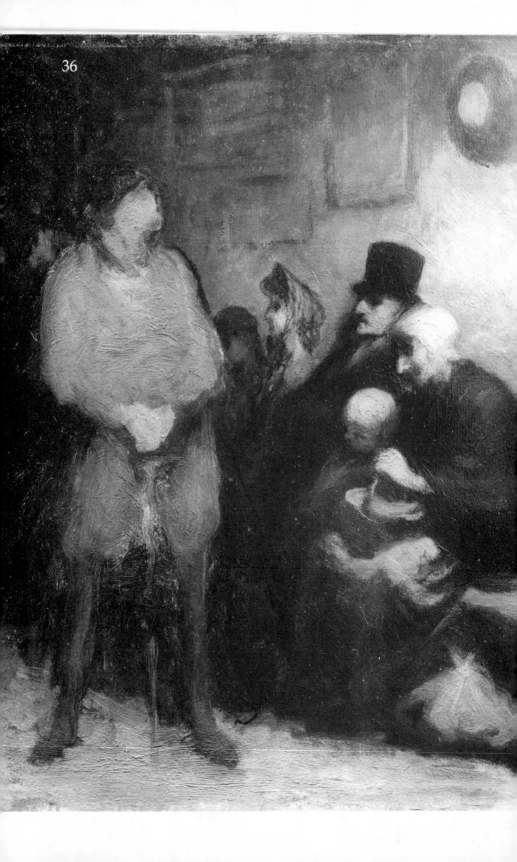

Daumier makes it clear that this is no ordinary chess game (37). By contrasting black and white, by composing a cross in the background, and by the tense expression of the players, he conveys the feeling that these aged men are playing for life. Perhaps one of them has a fatal illness which brings him to struggle with death. Or perhaps he is a doctor playing to gain time for his patient.

Daumier's theme of the waiting room (36) may symbolize waiting for the final departure, death. People from all walks of life and from old age to infancy are mingled together in the same common situation. The main themes in the picture are the patiently resigned old woman and the taut standing figure eyeing the wall clock. The man's skull-like head is featureless with only faint indications of the eyes. The wall clock is also faceless. Only the standing man can judge the time remaining for the waiting passengers. Below the clock, the light sphere leads to the old woman whose belongings are carefully packed for the departure.

9. The Wisdom of Old Age

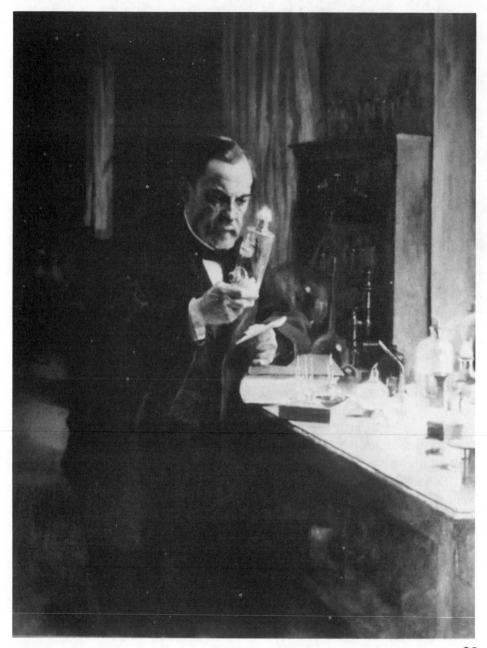

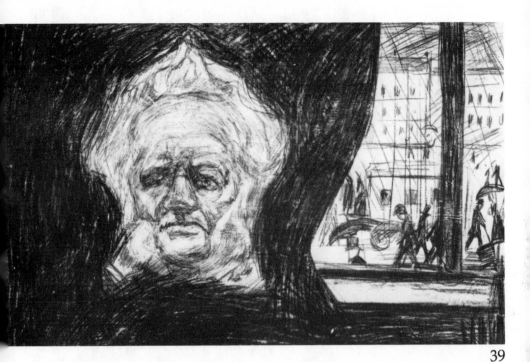

Do We Grow Wise or Senile?

The negative outlook on old age often suggests that senility is an inevitable consequence of aging. However, the outlook for mental growth and creativity in old age is far better than the popular negative stereotypes would suggest. Many representations of old age in art remind us of this.

Many significant discoveries have been made by elderly scientists. This portrait of Louis Pasteur (38) conveys his inventive mind and perseverance which enabled him to make a fundamental scientific discovery of a method for destroying disease-producing bacteria.

Henrik Ibsen, a Norwegian dramatist and poet, created many of his masterpieces at an advanced age. A man far ahead of his times, Ibsen unveiled truths which society preferred to keep hidden. He rebelled against society's conventions and empty traditions which restrict intellectual, artistic, and spiritual growth. Munch portrayed Ibsen in his familiar surroundings in the Cafe of the Grand Hotel in Kristiania (39). The lively street in the background contrasts with Ibsen's sturdy, immobile figure. The drama of life seems to be captured by the creative strength of the poet's mind.

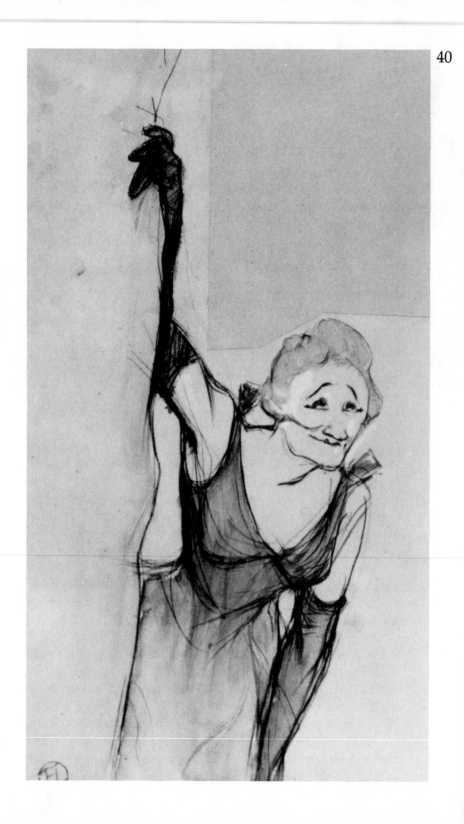

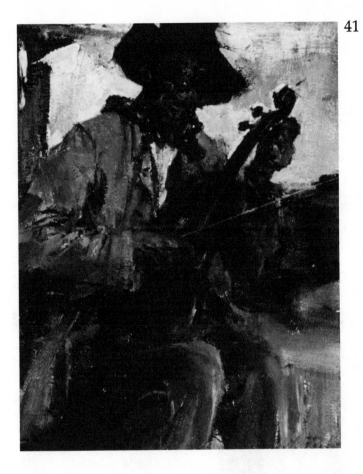

The Elderly Maintain Their Creativity

These aged persons, an actress and a fiddler, represent different fields of creative expression. Each one's art requires well-developed special skills based on physical, spiritual, and emotional sources of human endeavor. Singing and acting or playing the violin all require physical precision accompanied by creative expression. These elderly people exhibit abilities that are far from the stereotypic image of senility (40,41).

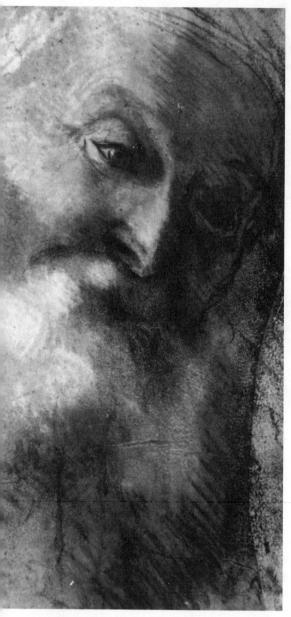

Life review may take the form of recalling important or especially meaningful events from one's past life. At other times it consists of reconstructing the main threads of one's life story. In both forms, the process enables the aging person to evaluate past events, activities, successes, and failures within the context of his or her whole life. In this way, unresolved conflicts are often put to rest. A sense of the meaningfulness and value of the unique individual life we have lived is achieved. Sometimes, however, the process can be characterized more by regret and despair than resolution.

Barocci's portrait of an old man (42) expresses the fulfillment of a satisfying life review. The face of the old woman in Rembrandt's painting (43) may reflect the regret that can sometimes accompany life review, the feeling of "If only . . ."

42

Looking Back: Life Review

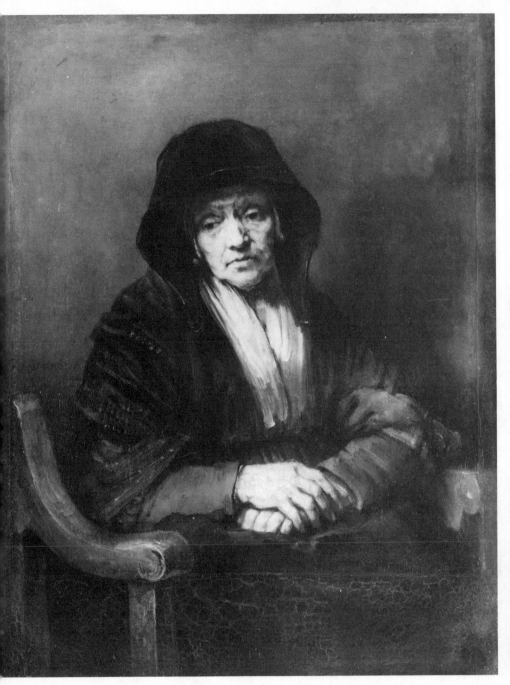

43

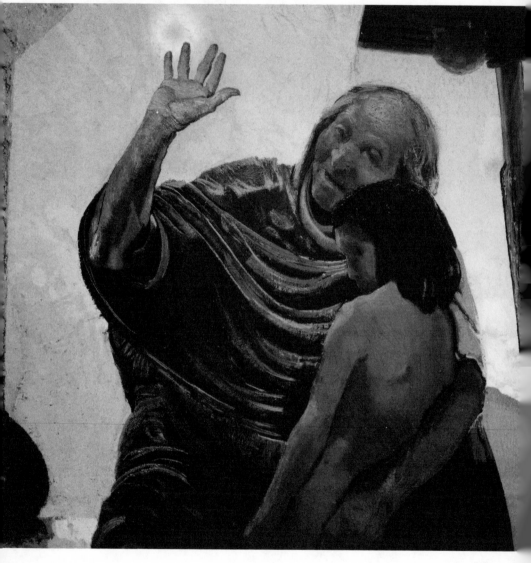

44

Heritage Is Sharing Your Story

When shared in the form of storytelling, life review may give the aging person a strong sense of continuity with the future. For telling the story of the past can serve as a vehicle for passing on many of our basic values, beliefs, and traditions to the oncoming generation. This gives many elderly people a sense of continuity with the future, and a fundamental source of satisfaction in old age. Blumenschein presents this kind of life review in his painting of an old American Indian story teller (44).

The activity of life review carried on by the aging person can have an irreplaceable value for the members of the aging person's community. For in life review it is not only the aging person's own individual past that is recaptured. The historical sources of our own existence and our cultural heritage are reiterated and reaffirmed. This is the case with the rune singer and repositor of tradition, Laren Paraske, a Finnish folk artist who could perform 1343 poems and verses. Her repertoire included approximately 32,000 lines of folk poetry (45).

The Ox and the Ass

The traditional meaning of the Nativity scene is "peace on earth." The different age groups represented—newborn Child, adult Mother and elderly St. Joseph—symbolize the unity of interest among different generations. The presence of the ox and ass in the scene symbolizes the resolution of religious conflicts, since those animals are the traditional symbols of conflicting pagan religions. These themes are beautifully expressed in Schongauer's *Holy Family* (46).

In the expression of the theme of earthly peace, the elderly St. Joseph has an important role. For the resolution of conflicts often requires insight into common values which can bring different groups together in a common purpose, and this kind of insight most frequently comes to us in old age. Perhaps that is why nations have so often entrusted important diplomatic missions to their elderly statesmen.

46 ▶

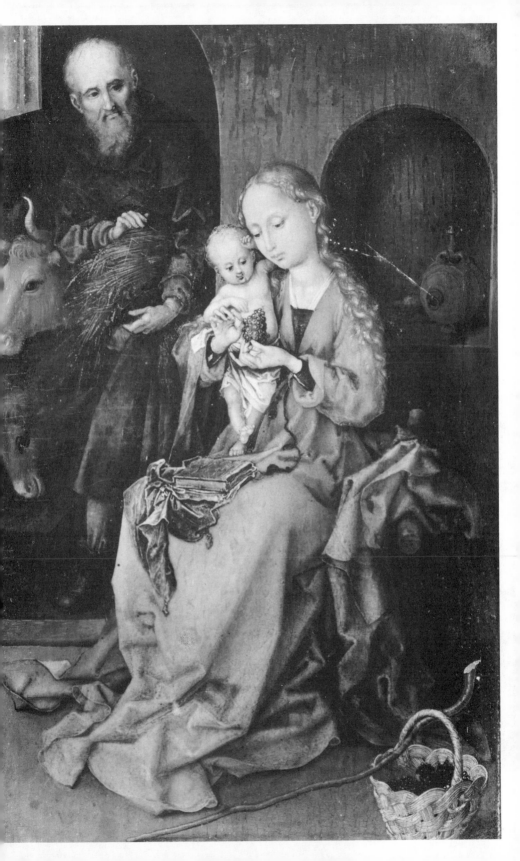

Harmony and Discord

The young ballerinas need the old violinist's music to coordinate their movements into a unified, harmonious performance. The scene in Degas's *The Rehearsal* (47) accents the virtuosity of the old man as the symbol of integrative understanding. He represents the ability to reconcile differences and create group harmony in pursuit of a common goal.

47

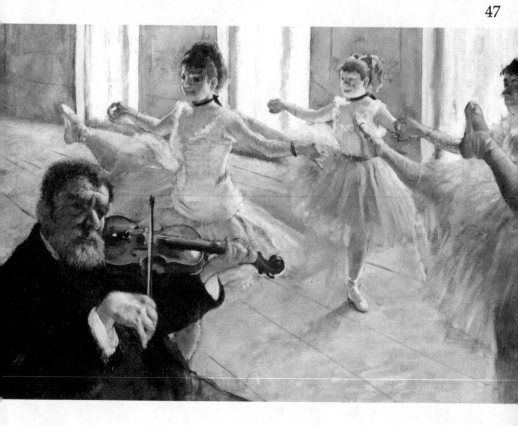

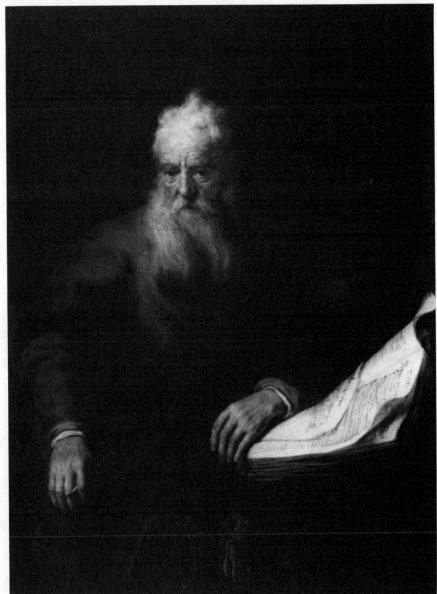

48

When I have ceased to break my wings
Against the faultiness of things.
And learned that compromises wait
Behind each hardly opened gate,
When I can look Life in the eyes,
Grown calm and very coldly wise,
Life will have given me the Truth,
And taken in exchange—my youth.

Sara Teasdale, *Wisdom*

Let a Thousand Flowers Bloom: Universal Perspective

In order to resolve society's most threatening conflicts, mankind will need the special ability for empathetic judgment which the elderly often have. This capacity is an inherent part of the wisdom of age, and has often been explored in visual interpretations of the parable of the Prodigal Son. None of these is more adequate to the idea of universal empathy than Van Baburen's *Prodigal Son* (49).

49

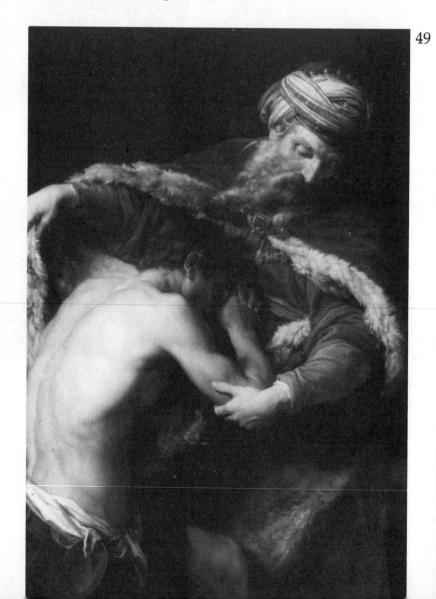

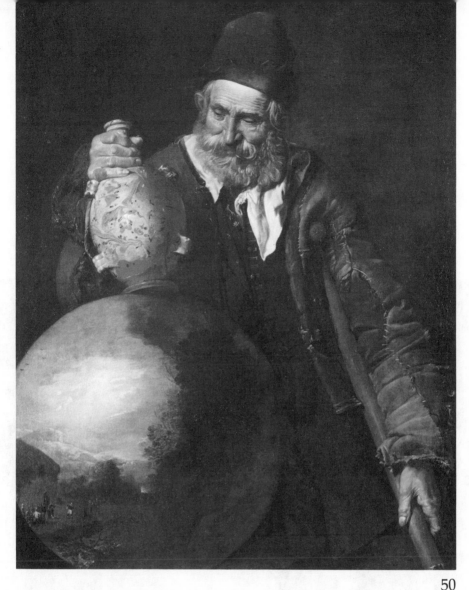

Mental Challenge

The seventeenth-century Italian painting *An Old Man Holding a Pilgrim Bottle* (50) interprets old age as a time of mental challenge. The aging person stands at a crossroad—a position of ambivalence between despair and decline on the one hand and renewed affirmation and life on the other. The experience of such inner division is the most important idea expressed in this painting. The old man is crippled on one side and must be supported by a crutch. On the vital side he holds a pilgrim bottle and turns his smiling face toward a waiting world which challenges him to a new quest.

10. Generations

The Necessary Link between Generations

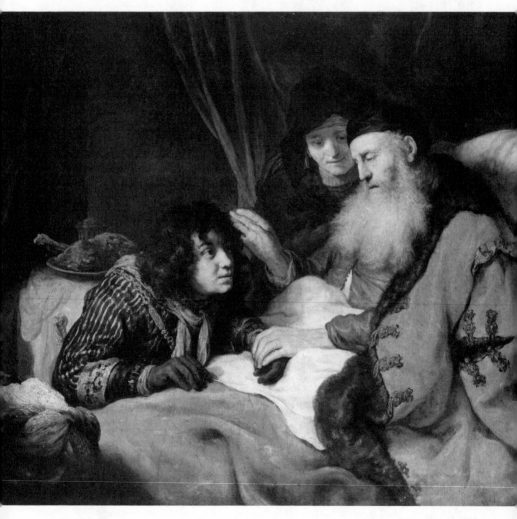

Passing on Cultural Forms

The role of the elderly in passing cultural forms on to succeeding generations is represented in numerous paintings. In the picture by Flinck (51) an elderly person is shown engaged in a ritual of passage in which important forms of status and legitimacy are conferred upon the young.

The transmission of cultural forms is an essential link between old and young. Artists have interpreted it not only as a basic need of the elderly but as a necessity for the development and well-being of society.

Bellows portrays his models—presumably granddaughter, grandmother, and great-grandmother—in Victorian dresses in order to stress the passage of tradition (53). Jansson (52) expresses the same idea by placing his cardplayers in the cabin of a fishing ship full of objects related to culture—a situation of isolation in which transmitting and adopting cultural forms intensively occurs. The central activity here is not learning to play cards but inheriting a philosophy of working companionship and of being an individual within an age-integrated social group.

53

Transmitting Wisdom

Velazquez depicts an old man selling water in the streets of Seville (54). The oval composition holds three persons— three ages of man. The middle-aged man in the center, drinking water, is in shadow. The young boy and the old man are illuminated, and are seen sharing a moment of thoughtful conversation. The clear glass of water which contains a fig to keep the water fresh connects the hands of the old and the young. The fig symbolizes the Tree of Knowledge from which the old man offers wisdom and spiritual life to the boy. From his urn he distributes the water of consciousness: the understanding that all men are brothers.

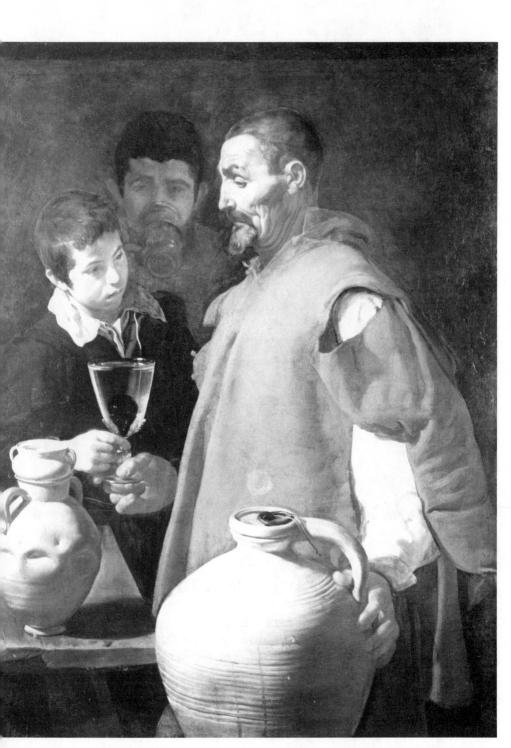

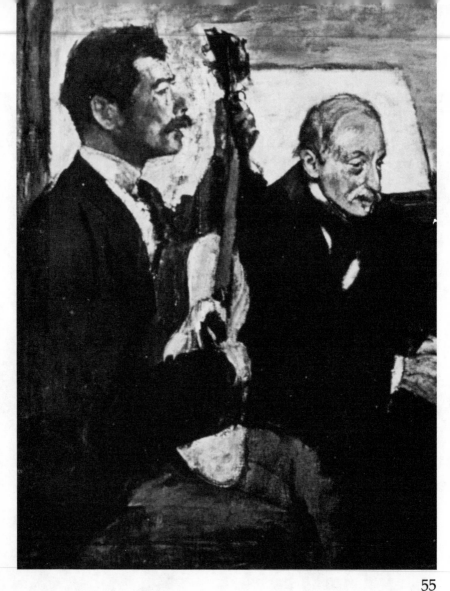

Our Need for Blessing:
The Confirmational Role of the Elderly

This scene of a younger man playing a guitar for his old father by Degas (55) holds more than the entertainment and enchantment of a musical event. The old man listening to the younger man play performs the role of a supportive adult. The guitar player needs recognition for his achievement and the sense of being valorized by the elder person. The approval and blessing of elderly parents is something all younger adults need.

A Helper and Teacher

In Daumier's *Advice to a Young Artist*, a veteran expert is studying the portfolio of the young man who has come for guidance and counsel. The setting is less formal than a studio, and the relationship between the two men is easy and comfortable. This suggests that the relationship has more range than in the ordinary association of teacher and student. The teacher in this picture symbolizes the role of the elderly person as a helper and adviser of young people (56).

56

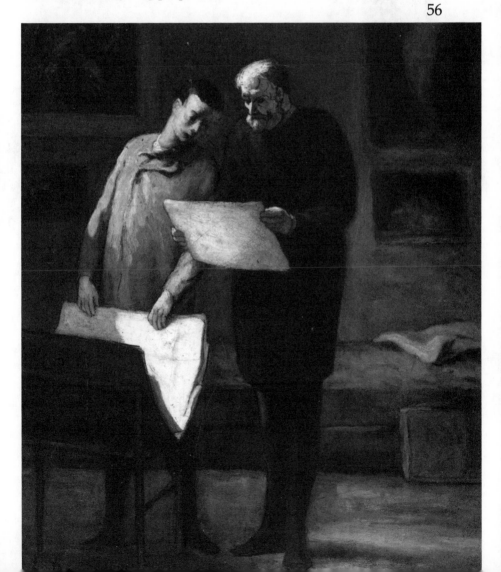

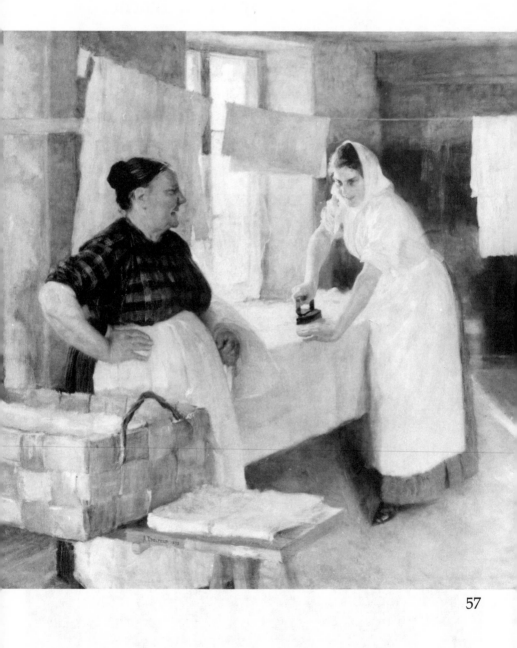

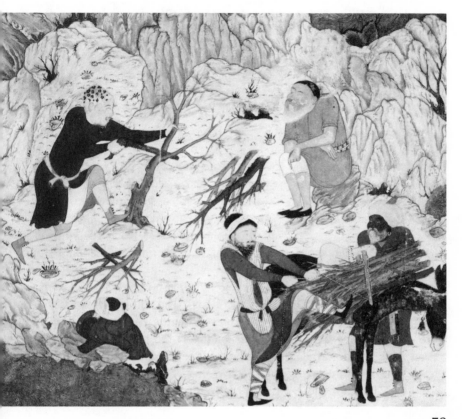

58

Elderly Gain in Authority

Two women enjoy a cheerful conversation in the sunny laundry room of Edelfeldt's painting *Washerwomen* (57). The young woman may receive a rich variety of practical knowledge as well as useful advice about life from the older woman. In many societies women gain a status and respect as they age and acquire a greater degree of freedom than in their younger days.

An Islamic miniature from the fifteenth century shows two old men, not engaging in the actual work under way, but apparently giving directions and advice (58). In many early societies, old age held the promise of prestige and authority. The longer experience of elderly people brought an element of wisdom into intergenerational relationships and their advice was valued.

11. The Elderly in the Community

Easy and Uneasy Relations

Affection and love permeates the scene of a big family of grandparents and their children and grandchildren. The sunny day, playful pets, and blooming garden strengthen the feeling of warm and easy relations among the family members. This summer place was an enjoyable retreat for Bonnard, who depicted such happy and joyful family gatherings in this and many other paintings (59).

The family portrait by Por (60) represents an old couple with their children and grandchildren. The family members show no cohesion; instead they express isolation and anxiety. The old woman at the center of the family is the most tense, crossing her arms forbiddingly against our approach. This image is a stark contrast to those which express the idea of stronger family bonds in old age (23, 30, 44, 59, 65).

59

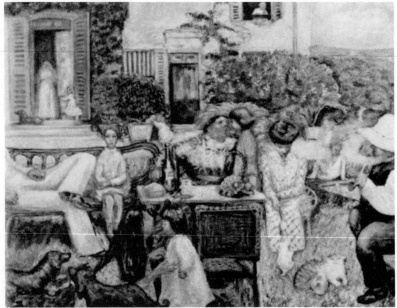

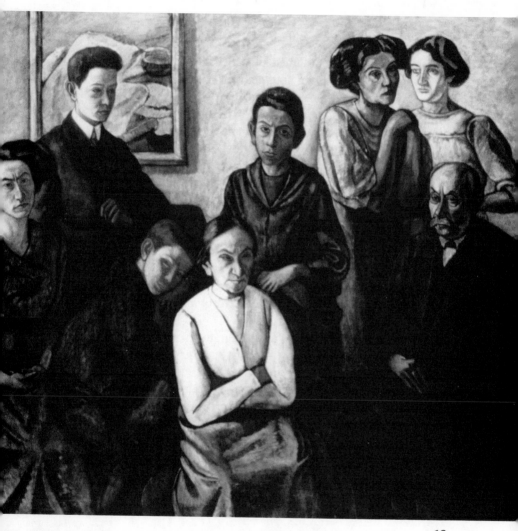

60

The Elderly Involved in the Community's Life Activities

It is often assumed that the elderly prefer age-integrated living arrangements, and that they favor the return to the extended family in which many generations live in the same house. These ideas are disproved by gerontological research. The aged prefer to live near but not with their grown children and their families. Most retired persons seem to prefer living in communities with people their own age—such as retirement communities—rather than in mixed neighborhoods. On the other hand, some age-segregating practices are objectionable to the elderly and have had devastating effects on them. In general, when the elderly are segregated without consideration of their own interests and desire, it may be discriminatory.

The ideal of an age-integrated society is shown in this fifteenth-century tapestry which portrays two elderly men involved in a community activity—hunting the mythical unicorn (61). The man wielding the sacrificial spear at the right is of advanced age. So is the man in the left upper corner, who brings water which the unicorn will change into a wholesome beverage.

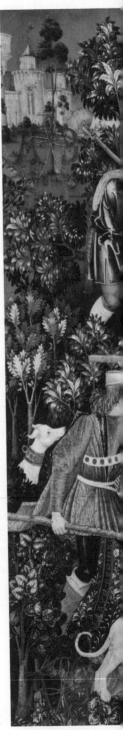

61

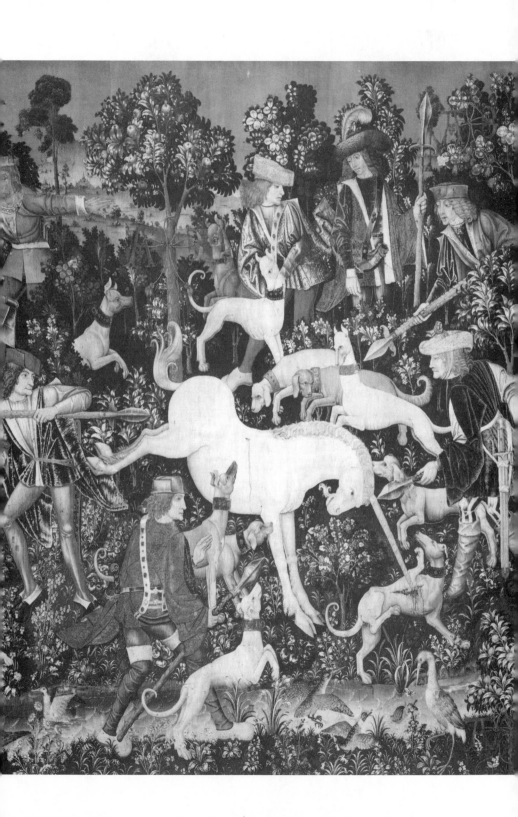

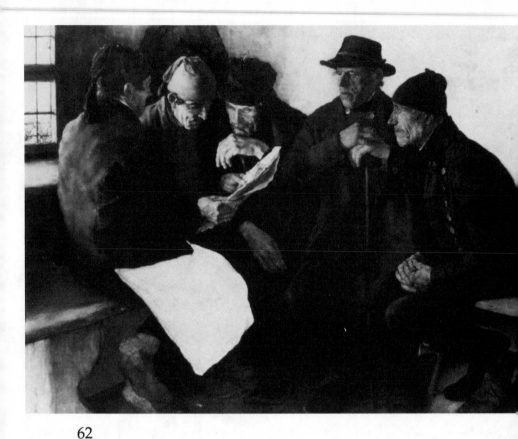

62

Leibl depicts a group of elderly men who enthusiastically examine the newspaper and ponder local politics (62). Their keen interest indicates that they are active in civic matters and participate in decision making. They meet in the home of the village baker who wears a white apron and no shoes. In old age they have a well-earned opportunity to enjoy activities other than work and to stay involved in the community's activities.

Among the snow shovellers depicted by Munch (63) we see an old man. The artist has placed a group of three men in the foreground balanced by the figure of the old man on the right. The composition affirms the importance of including the elderly in the mainstream of community life.

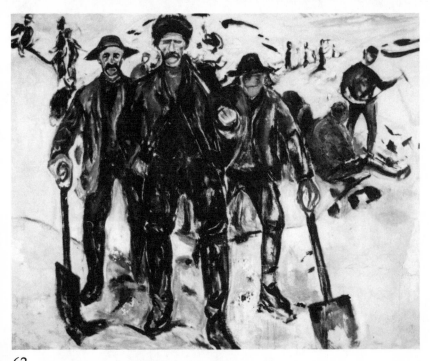

63

The Elderly Segregated

In contrast to pictures of the socially integrated elderly, this image by Leiberman of a an old men's home in Amsterdam conveys a feeling of the loneliness and decline that can result from undesired segregation of the elderly.

64

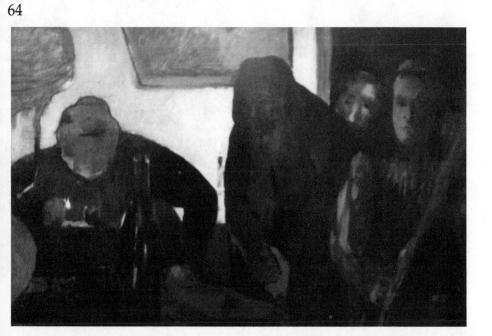

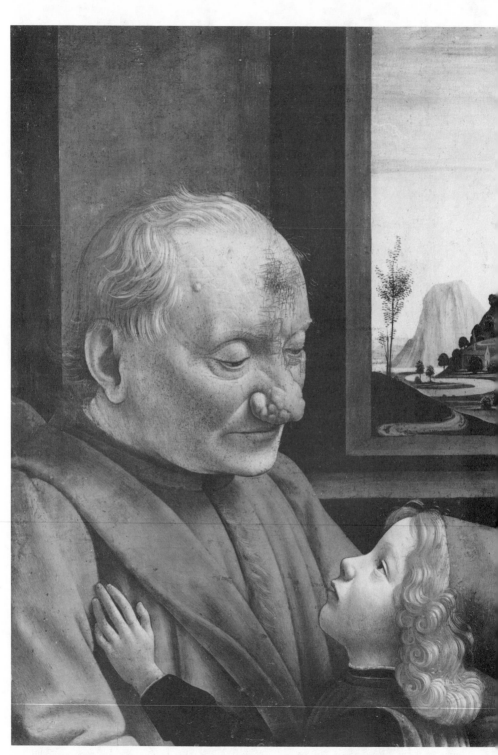

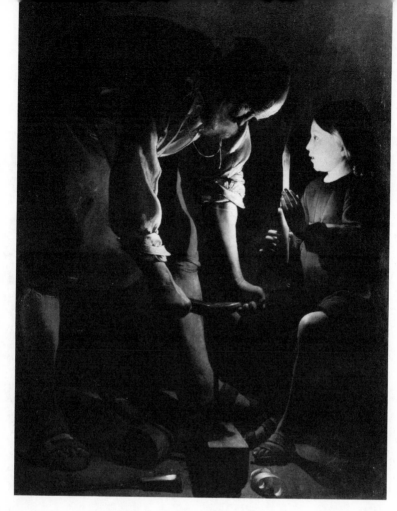

66

Giving and Receiving:
Intergenerational Exchange

Ghirlandaio (65) depicts the mutual affection and respect between the old man and his grandson with great intensity. A tender human relationship of love and trust is expressed in their exchange. The shadowy dark walls and the landscape where a river meanders into the horizon brings the melancholy note of inevitable separation to the picture.

La Tour (66) gives a convincing example of reciprocity and affection between and old man and a child—much the same feeling as in Ghirlandajo's painting *An Old Man and His Grandson*. The old man gives and the boy receives a valuable lesson in carpentry. But there is mutual exchange. The child's affection and desire to help enhance the dignity and importance of the old man.

Velazquez shows us an old woman cooking a meal with her grandson (67). They seem to share their work and help each other not just at the level of their physical task but also mentally and emotionally. The attentiveness of the boy and the responsiveness of the old woman express a feeling of giving and receiving between youth and old age.

67

To children, going to Grandma's establishes a natural tie with a bygone time. Grandparents' stories provide a sense of connection with still older times. In Picasso's picture *Reading* (68), the grandmother's story has transported the grandson to an imaginary time in the eighteenth century.

Pleasurable leisure activity and playfulness tends to dominate the interaction of grandparents and grandchildren. Grandparents may engage in play activities relating to the interests of children at any age, as in Champney's picture *Boon Companions* (69). While the unpleasant task of disciplining is left to parents, grandparents can enjoy indulging their grandchildren to the point of spoiling them.

69

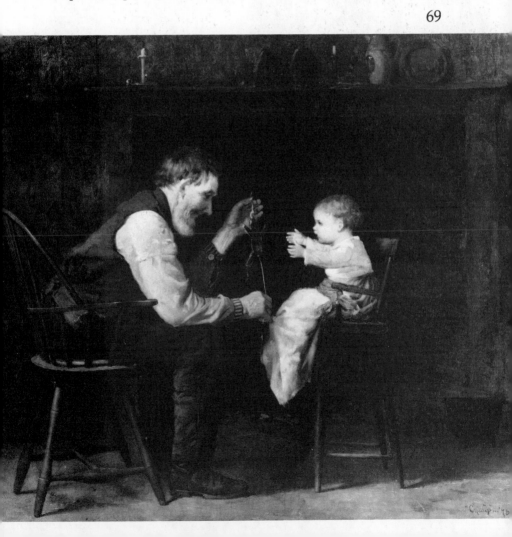

In this picture (70) grandmother and her baby grandchild enjoy a meal together. Vuillard sensitively captures the mutual acceptance and affection between them. The picture also conveys the secret of success in relationships between the generations which lies in achieving and maintaining autonomy as persons, whatever one's age or generation.

70

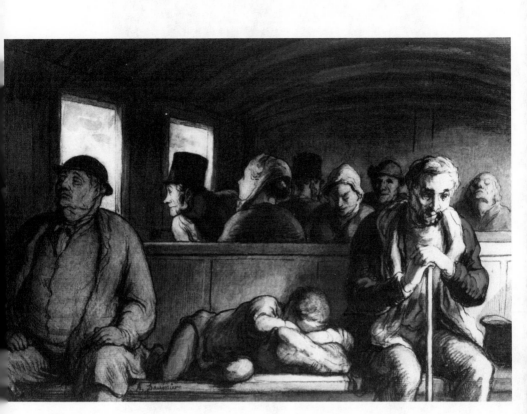

71

The Ages of Life

Daumier's *Third Class Carriage* shows us a corner of a gloomy railway compartment occupied by passengers on the journey to their destination (71). The triangular composition and the bilateral lighting differentiate three aged men who portray three stages of old age. In the first row, left, a man sits in shadow. His pose and the expression of his face suggest depression and weariness on the threshold of inevitable old age. The man behind him has passed his anxiety about old age and looks out the window. Sunshine creates enlightenment on his alert, observant face. His pose tells of an active attitude toward life which offers him a variety of interests and vivid experiences. The sleeping child leads us to look at the third man leaning on his cane. His eyes look inward, pondering life, and he is as lost in his thoughts as the sleeping child in his dream.

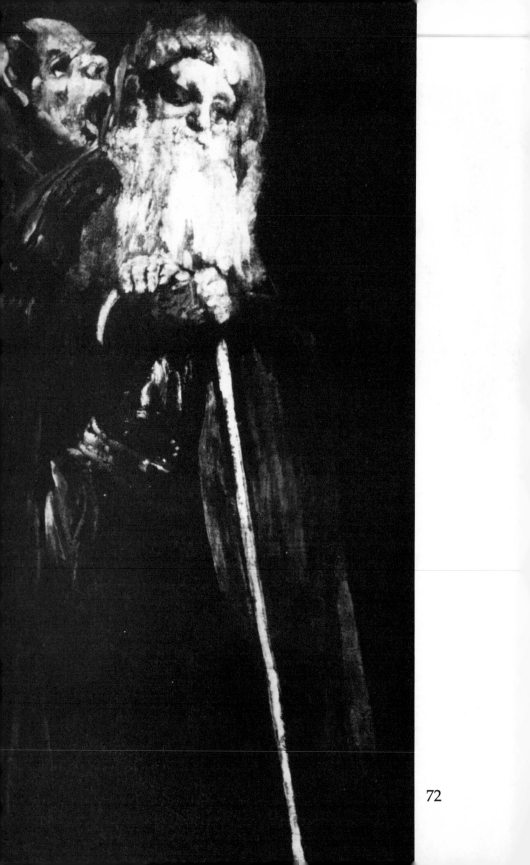

72

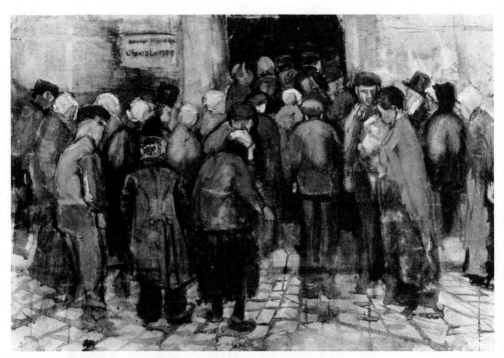

73

Dependency

Goya often explored the darker, forboding side of life in his paintings. In his work *Two Old Friars* (72) his theme is dependency in old age. The dependency of these begging monks is twofold. They are dependent on the charity of passersby and on each other. The resigned, pitiful appearance of the white-haired and bearded monk is used as a front by the other one who does the actual mendicancy.

Hard times can be especially difficult for the elderly, whose material resources are often very limited. Among the crowd at the state lottery office we see many aged persons who resort to gambling in a desperate effort to escape from poverty (73).

12. Old Age in Myths
Old Mother

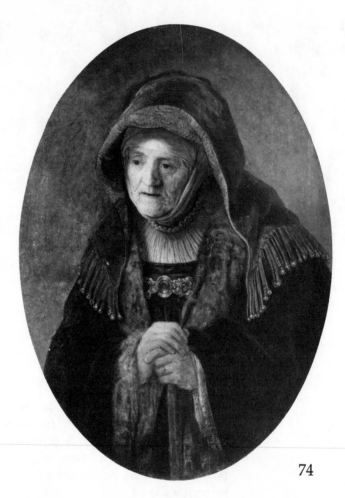

74

Rembrandt's mother (74) displays introspective qualities in a thoughtful moment of repose. Placed within the perfection of the oval form, the old mother leans on her cane, her face and hands highlighted. Her carefully depicted fine dress suggests the material possessions the artist was able to provide for his mother after his transformation from a miller's son to an elegant Amsterdam gentleman. Although absorbed in her thoughts and memories, the old woman's pose is kind and inviting.

75

Vuillard (75) portrays his mother as a strong, dominating matriarch. The artist's sister turns toward the mother in a position which suggests a humble bow. Although she is a rather forbidding figure, we can also sense empathy and understanding within the mother.

Whistler's portrait of his mother (76) is his best known work. In executing it Whistler tried to avoid any sentimentality or literary statement in favor of a highly formal study. Nevertheless, the portrait conveys a feeling of resignation and loneliness in this beautiful and noble-featured aged woman.

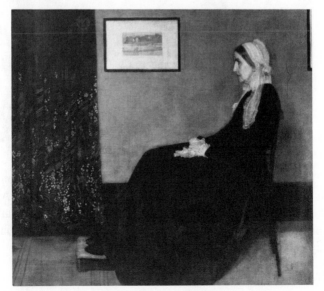

76

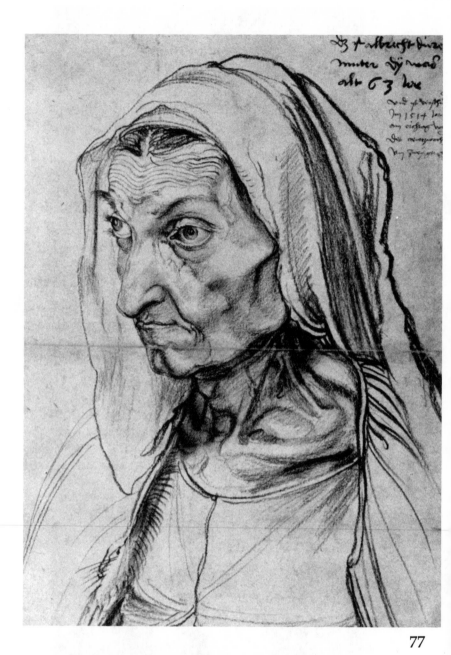

77

Dürer drew his mother with much love and devotion, expressing her unusual determination and sincerity (77). At the time of the portrait, Dürer was in the prime of his artistic maturity and drawing his mother may have been a special appreciative gesture.

78

Thoma depicted his mother reading at an open window.
Bright sunshine illuminates the room, the sturdy little woman,
and her book. Her personality reflects amazing mental and phys-
ical strength. Like the window, her mind is open to the world
outside (78).

Growing Old Together

Grosz depicts a married couple walking together (79). In old age they have become alike. They stand for the idea of growing old together as firmly as they cling to their personal attributes, a cigar and walking stick, a handbag and shopping bag. Although the loss of the spouse and solitary life in the later years is common, the myth of growing old together persists in our beliefs about old age.

Grandmother's House

Maes depicts a typical scene we tend to associate with the idea of grandmother's house (80). The interior and the praying woman's dress speak of well-being. The hourglass, bell, and keys refer to the wisdom and inner rewards of long life. The simple table setting with its tin plate and a porcelain pitcher, and the plain but nourishing meal, both suggest the honest bounty of her simple and pious life. The old woman's companion, a cat, reaches for a share of the meal. His sharp claws on the tablecloth and the knife pointed towards the woman indicate that there is also a vulnerable, tenuous side to her life.

80

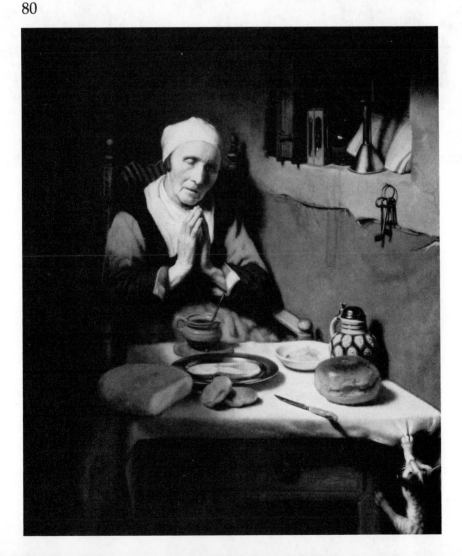

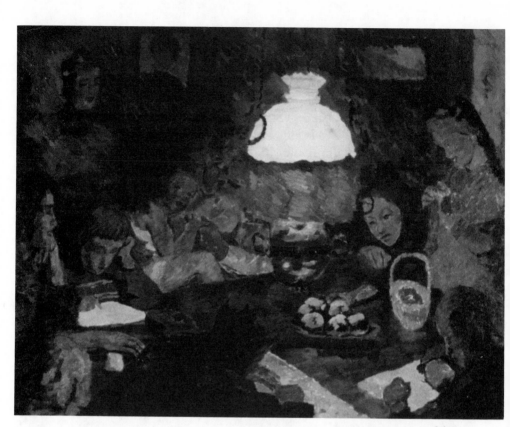

81

The Selfless Elderly

In Giacometti's painting (81) a big family is gathered together around a lamp for various activities in the evening. A girl reads, a boy draws a picture, one studies a map, and another knits while engaging in a joyful chat. The elderly woman with a thoughtful gaze holds a child in her lap. In her we may see a selfless elderly person, a grandmother who is expected to accommodate and entertain her children and grandchildren whenever they have a need to escape from their daily worries.

Life Without Problems

Each of the elderly people portrayed here is engaged in a relaxing activity (82–86). The women crochet, manicure, and sweep the floor; the men are reading from a book or waiting for the next move in chess. Although these activities may seem casual and unimportant in themselves, they leave room for deep thought such as that which occurs in life review.

82

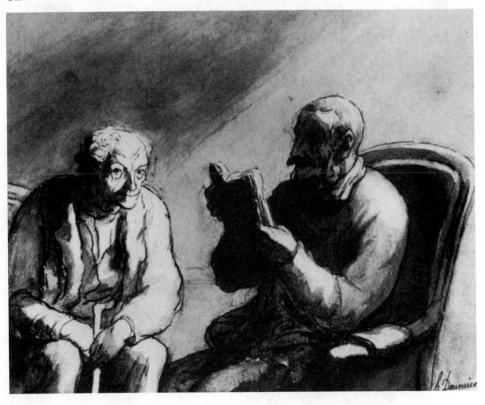

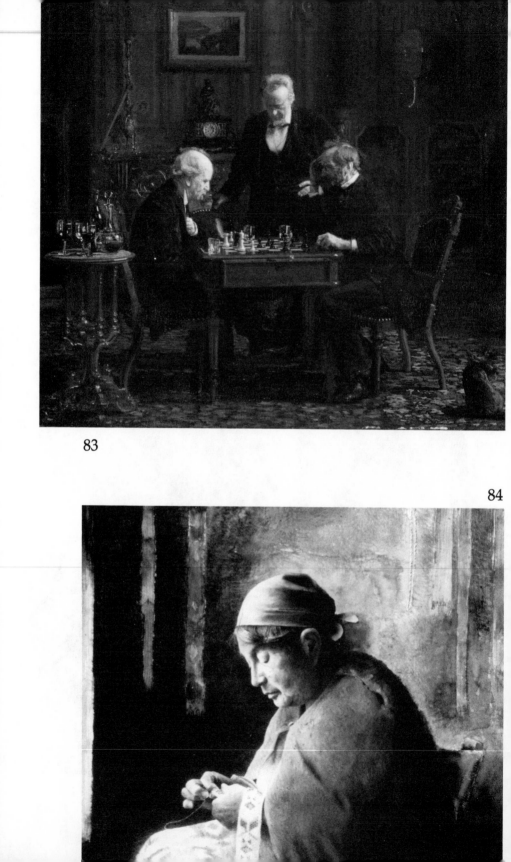

83

84

85

86

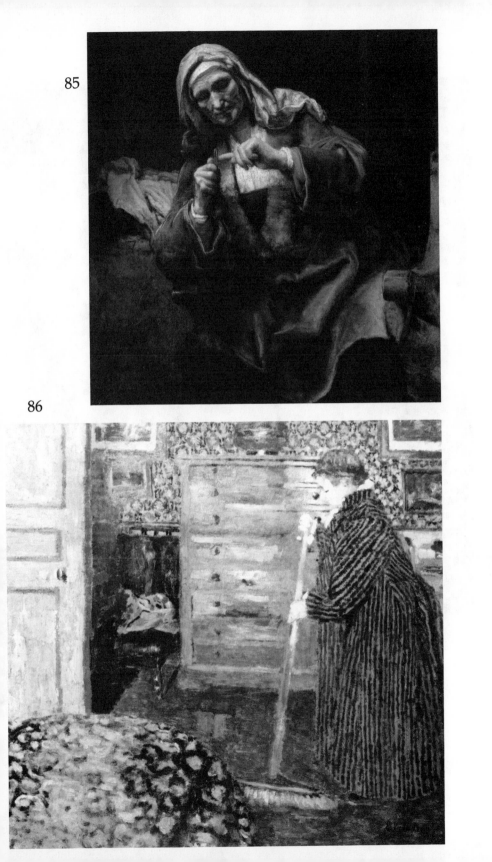

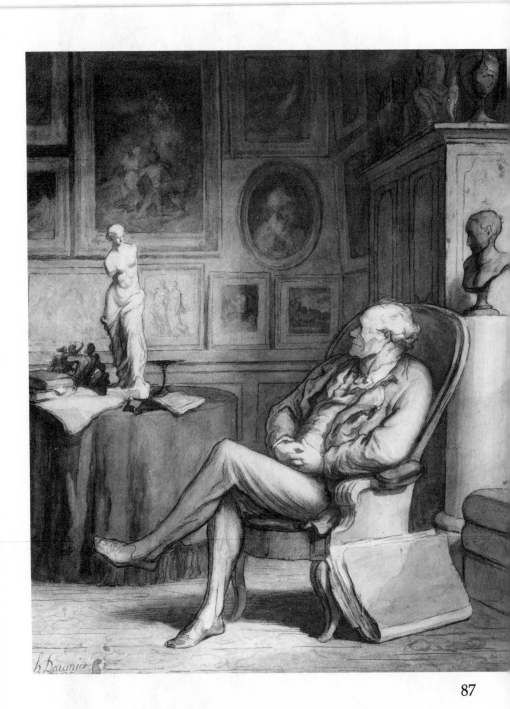

The Harvest Years

There is no doubt that these men—an amateur collector (87), tribesman (88), working man and scientist (90)—enjoy the gratification of work well done. They may well represent the kind of person of whom William Cowper speaks in his poem *Contemplation*.

> Therefore in Contemplation in his bliss,
> Whose power is such that whom she lifts from earth,
> She makes familiar with a heaven unseen,
> And shows him glories yet to be reveal'd.

Shuptrine portrays a bishop's wife in her old age (89). She sits in a rocking chair reading a book illuminated by gentle light. Her sturdy hands demonstrate that she has been engaged in countless chores and tasks besides her intellectual and spiritual activities. Her personality radiates integrity and serenity symbolized by the magnificent book she holds. In its well-considered simplicity the portrait conveys the idea of fullfillment a person achieves through a purposeful, active life.

La Nain depicts an elderly grandmother surrounded by her grandchildren. The children show their admiration and love for their grandmother in various ways. Two of the boys sing to her accompanied by the third boy. A little girl sits with adoring face as does the dog beside her. On the left, a girl very much like her grandmother may carry on her rewarding philosophy of life (91).

88

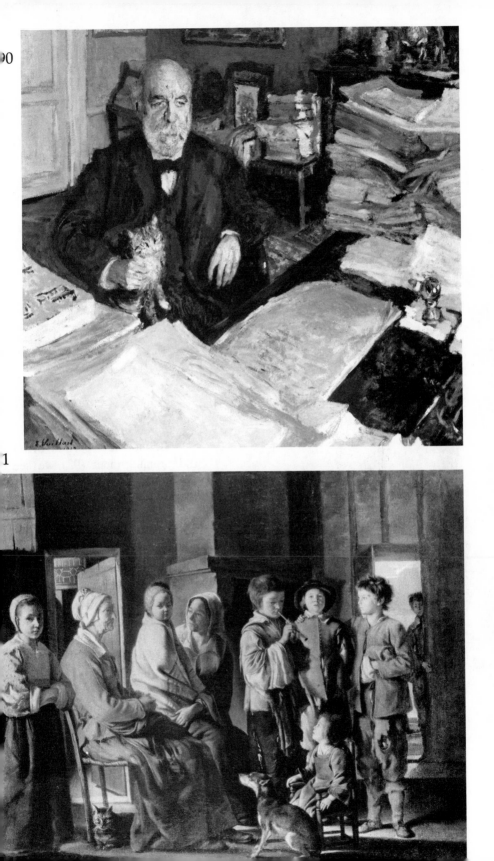

Old People Become Children Again

92

In Picasso's portrait of an old organ grinder (92) we see a different statement of the idea that old people can become like children again. Beside the old clown a young boy sits in a circus costume. The middle-aged generation is absent. The strong identification of the boy and the old man established by the similarity of their costumes and mood reminds us that in material poverty, dependency on the middle generation, and lack of authority over their own affairs, the elderly sometimes have a great deal in common with children.

93

The childlike smile of an old woman portrayed by Jansson (93) is that of a mentally alert person who has youthful wonder and curiosity about life. Her face expresses the same joy and happiness we see in children.

Sexlessness

The belief that sexual desire continues but tends to be thwarted and frustrated in late life, resulting in resentment of the physical perfection of youth, is expressed in many interpretations of the biblical story of Susanna and the Elders, here depicted by Reni (96). Another frequently depicted theme portrays the elderly person as voyeur. This theme represents the elderly as men and women who have interest in sex but whose old age has put any physical intimacy or relationship for themselves out of reach. An example is Rubens's *Angelica and the Hermit*, an image of longing for unattainable joy (95). In such works the elderly are often shown as seeking satisfaction of their continuing sexual needs by observing the relationships of other, younger people, as seen in Rubens's *Samson and Delilah* (94).

94

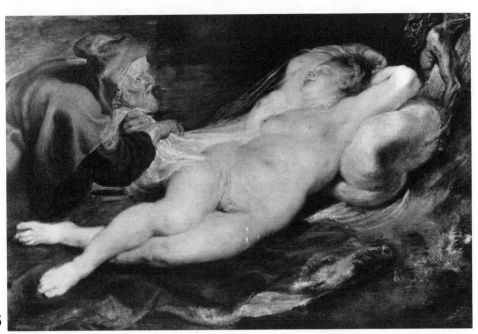

95

96

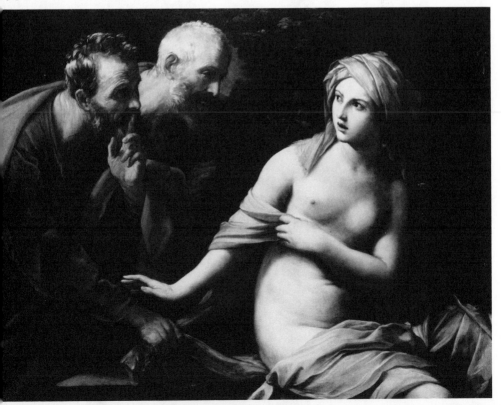

97

God the Father

In early Christian art it was considered a sacrilege to make an image of God. First only his hand emerging from a cloud was depicted. Gradually the whole figure was portrayed. God the Father is shown as a regal old man with long white hair and flowing beard.

Michelangelo's image of God is the mighty Lord of the Old Testament who appears in the cloud accompanied by angels, speaks with a voice of thunder, and sends forth lightening (98). He rules heaven and earth much as the pagan gods Zeus or Jupiter ruled their world.

In Blake's *God Judging Adam* (97), God is depicted appearing in a burning carriage. Like Michelangelo's image of God, his mien expresses omnipotence, yet also conveys divine gentleness.

98

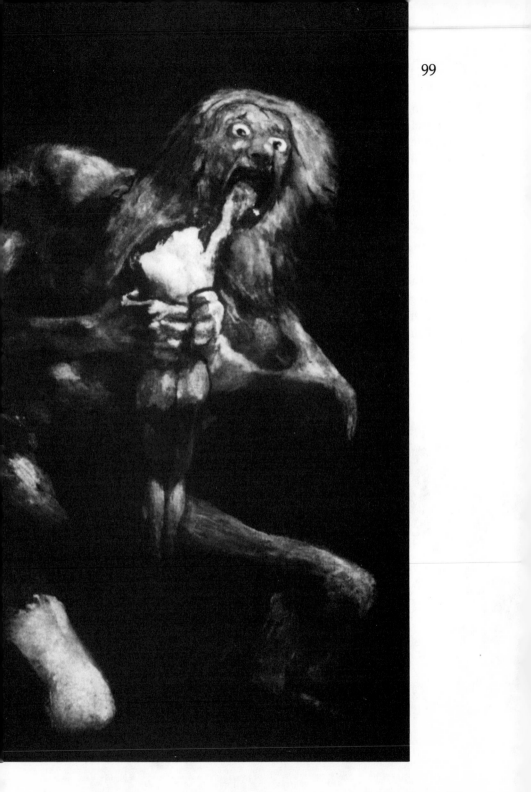

Father Time

Father Time, a personification recognizable by the characteristics of old age and a scythe, is known from classical mythology, and in today's popular image of the Old Year going out at New Year's Eve. No one has more effectively expressed this theme than Marcel Gromaire in his image *The Flemish Reaper* (100).

The metaphorical meaning of this picture is unusually poignant—an elderly workman sharpening a scythe, the universal symbol of time and its passage as well as the implement of time's inevitable partner, death.

This beautiful image also prompts us to reflect on the "artistry" of time that is embodied in every aged person. The transforming effect of time on this man's hands, head, and posture has given him a visual dignity in much the same way that time can enhance the look of an aged statue or building. He has been "sculpted" by the hand of time, and the result is a unique and moving beauty belonging only to the old.

Goya depicts the image of Time as a ferocious old man devouring his own children (99). In Greek legend, Cronous or Time ruled the world. Because he was fated to be overthrown by one of his children he devoured them as infants.

100

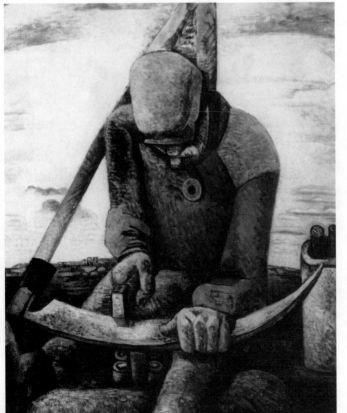

Time as the ultimate revealer of truth is a mythical theme found in many representations in art. With the passage of time, according to this myth, we will find the reasons and explanations for the various problems of life (101).

Batoni's painting (102) manifests a persistent myth that there is no beauty in old age and that elderly people are not considered beautiful. We tend to be blind to the special beauty of the aged person. In this allegory Time orders Old Age to destroy Beauty. Old Age in personification as an old woman grasps the face of Beauty to destroy her appearance, while Time, holding an hourglass, points out the victim. Beauty's pose and expression are passive and emotionless, suggesting the inevitability of time's destruction.

101

The Old River God

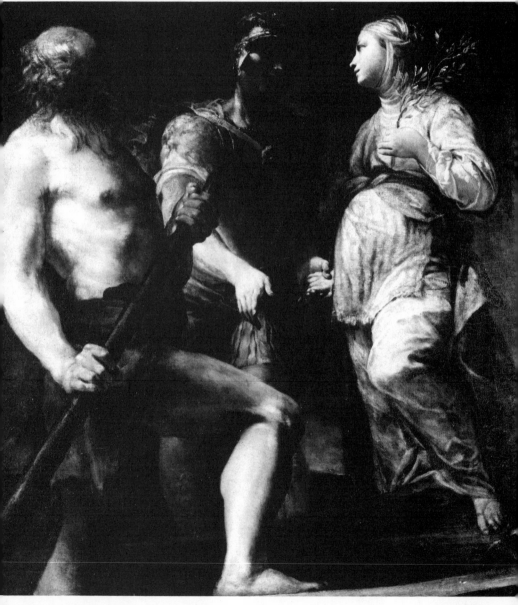

103

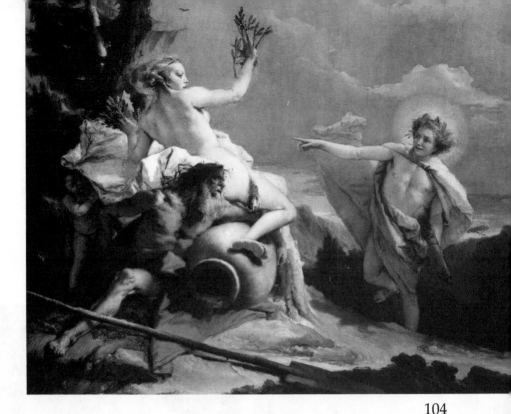

104

In Greek mythology, Charon was a sinister old man, who rowed the newly arrived dead across the river Styx to the Underworld, the kingdom of Hades. Charon was paid with the coin left in the mouth of each dead person. In this picture by Crespi (103) Charon takes Aeneas and Sybil to the world of the dead. Aeneas visited Sybil—an oracle—in her temple and prayed to be allowed to see his dead father once more. Protected by a branch of mistletoe, an ancient symbol of life, and guided by Sybil, Aeneas embarks on Charon's skiff.

Tiepolo's painting from Greek Mythology (104) depicts the river god Peneus as an old man giving refuge to his daughter the nymph Daphne. The old river god reclines over his overturned urn, an oar beside him to protect his daughter from the youthful Apollo. Branches sprout from her arms, roots grow from her feet, and, according to the mythical story, she changes into a laurel tree. Cupid, who struck Apollo with a golden arrow and kindled his love, hides behind Daphne while Apollo, crowned with laurel leaves, approaches. The theme symbolizes the victory of Chastity over Love through the help of the old father.

105

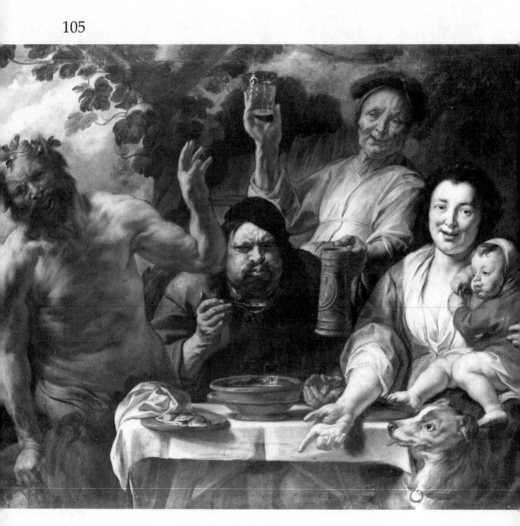

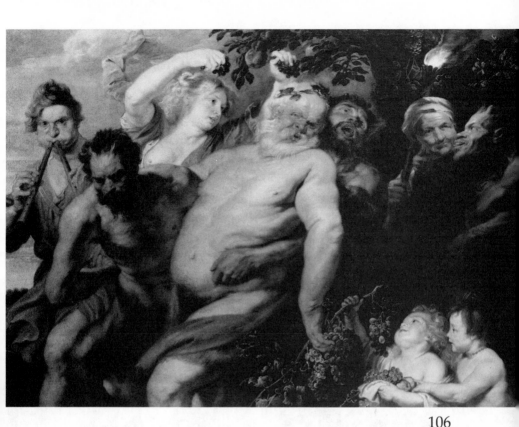

106

The mythical Satyrs were part bestial, part human creatures. The attendants of Dionysus, they were lustful and ebullient, always merrily drinking and dancing. In a fable, originated by Aesop and La Fontaine, a wayfarer was invited in from a cold wet night to have a supper with a Satyr and his family. The guest first blew on his cold hands to warm them, and then on his bowl of soup to cool it. "Go off!" said Satyr, "I don't trust a guest who blows both hot and cold." Jordaen's version of the popular myth (105) depicts a farmhouse kitchen where Satyr and his guest are at the table. Every family member, grandmother, wife, child, and son as well as the domestic animals listen to Satyr's remark.

In Greek mythology Silenius, the oldest of the Satyrs, had particular authority. He was a wise and profound spirit, but would reveal his knowledge only under extreme pressure. According to some myths, the Satyr was so perpetually stupefied with drink that he was unable to distinguish truth from falsehood. Silenius is usually represented as a drunken, jolly, bald, fat, and bearded old man, as in this scene by Rubens (106).

Philemon and Baucis

In Greek legend an old couple, Philemon and Baucis, opened their cottage to two strangers and shared their meager meal of bread and wine with the guests who had been turned away from wealthier houses. During the repast, the couple noticed that the wine jug was never empty and that their goose which they would have killed for the meal, flew to the visitors for refuge. The guests revealed themselves as the gods Zeus and Hermes, and promised to fulfill whatever request the old wife and her husband would like to make. Philemon and Baucis asked that they would be permitted to die at the same moment. And so it was. One day, Baucis quietly became a linden tree and Philemon an oak, their branches intertwined forever (107).

107

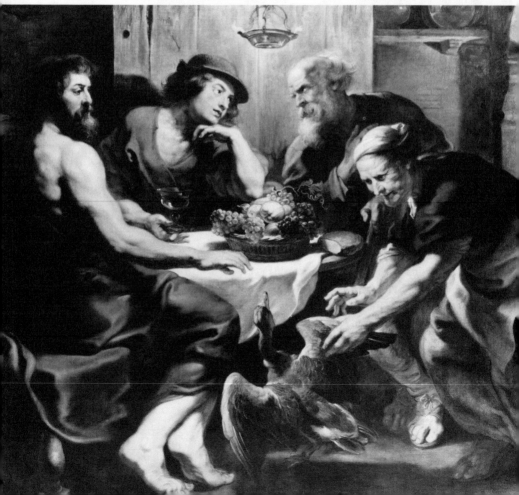

The Myth of the Hero

In mythology the hero is strong, courageous, and skillful, performing deeds of valor and overcoming Fate. The mythological hero displays great personal resourcefulness and initiative and wins an eminent position through extraordinary feats. He performs an act or deed which is destined to have never-ending consequences. The hero may have sinned, although unwittingly, and cannot escape his guilt. The myth of the hero lives in epics such as the Mesopotamian *Gilgamesh,* the Greek *Iliad and Odyssey,* the Old French *Song of Roland,* the Middle High German *Niebelungenlied,* the Icelandic *Edda* or the Finnish *Kalevala.* The years of action for most mythic heroes are those of youth or middle age. That is not the case with Vainamoinen, the hero of *The Kalevala,* who is referred to as "old and steadfast, being old even at birth." He is an eternal sage and a man of great knowledge.

Gallen-Kallela's picture shows Vainamoinen fighting with the witch Louhi, Dame of the North, over the possession of Sampo, the prosperity-producing mill (108). Louhi transformed herself into an eagle, whose "one wing brushed the clouds, the other grazed the water."

4

Pegazos

110

Witches

Witches, who exercise supernatural powers mainly for evil purposes, are found in human culture since pre-Christian times. Witchcraft still survives in technologically developed and in less developed societies. Although witches were of all ages, the most common age was fifty to sixty.

Goya depicts two aged witches dancing and leaping in the air (109). The ritual dances of witches had the character of folk dances with sudden springs through the air.

In popular belief most witches are old women. A typical expression of this belief is found in Rykaert's picture *The Witch* (110).

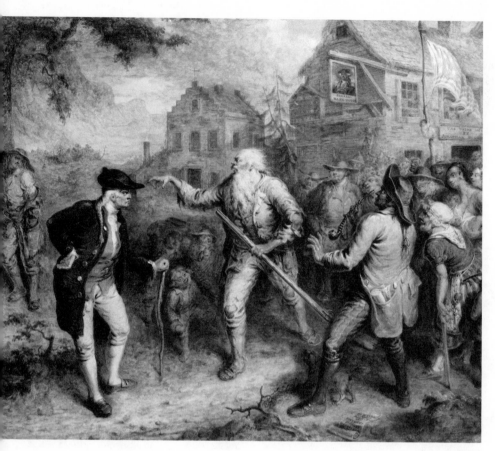

The Wasted Years

In this scene by Quidor, Rip Van Winkle returns after his long sleep. It was with some difficulty that he found the way to his own home. "I was myself last night, but I fell asleep on the mountains and everything is changed and I am changed and I can't tell what's my name or who I am. I'm not myself, I'm somebody else" (111).

The Old Person as Seer

Fortune-telling, palmistry, and astrology are occult ways of gaining information about the future. In folk literature the elderly are often represented as having powers of foresight or other occult knowledge. They have been represented as possessing gifts in mediating between human beings and supernatural powers, treating diseases, exorcising evil spirits, divining the future, or controlling the weather.

The peasant women depicted by Rissanen (112) share the excitement when the aged seer reads their hands in turn. She keenly examines the gaze, mien, and gestures of the younger woman. Through her experience and knowledge of human nature and its bodily expressions, she may gather accurate and revealing information about her subject.

112

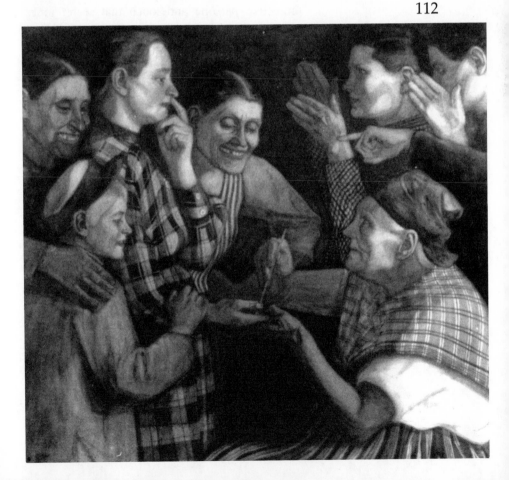

As we have seen, the elderly person is of-
ten represented in the role of circus clown. This
anonymous fifteenth-century Netherlands paint-
ing gives one version of that theme (113). What
is shown here is the old clown's ability to see
into the human heart, to pierce the armor of our
protective persona and touch that secret inner
place that makes us laugh or cry, even against
our will. A dispossessed wanderer, the old
clown represents all those who are without
wealth, social position, or power, but who are
nevertheless rich in the knowledge of who we
really are.

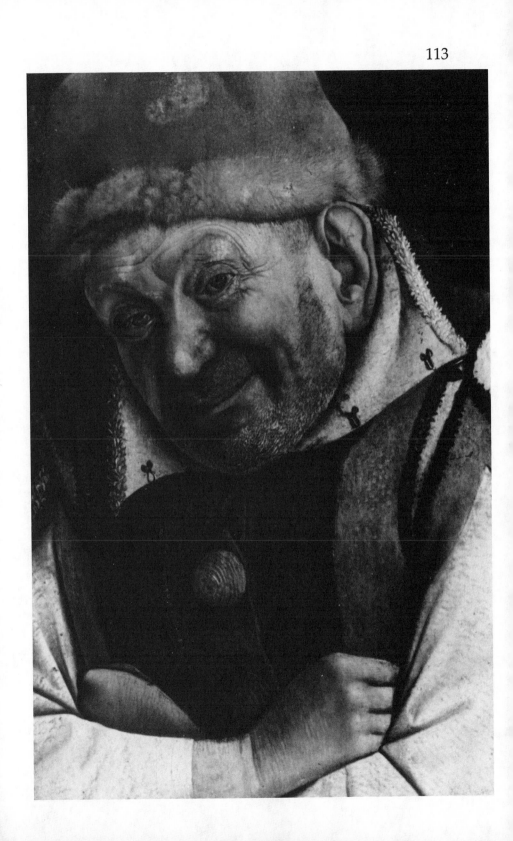

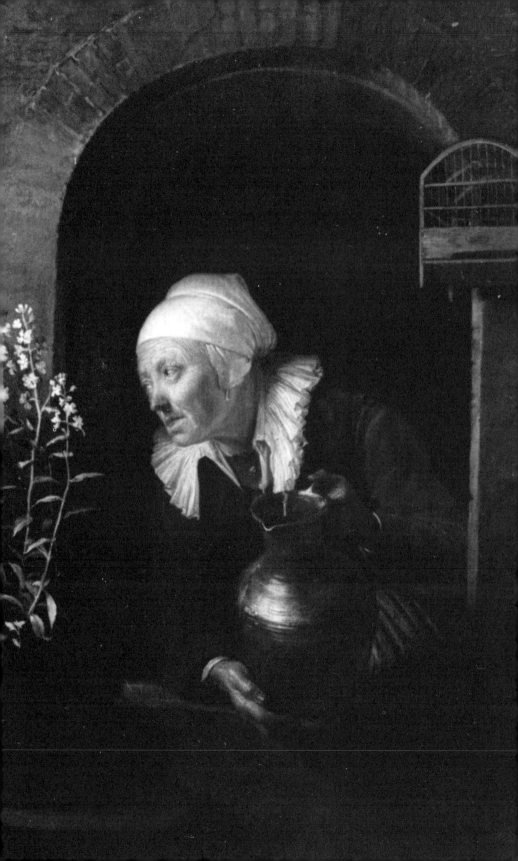

In his picture *Old Woman in a Window,* Gerrit Dou shows us an aging woman moving from a confined and darkened interior to a larger world of sunlight beyond (114). As she crosses the symbolic division between these worlds, she reaches out to nurture some flowers with water—that symbol of the wisdom and reaffirmation of life in old age that we have encountered so often in this book. Many artists have seen old age as a time of passage from a life of relative darkness and confinement to a life more illuminated by understanding and freedom, in which we can both give and receive more abundant life. Perhaps, as this image suggests, no human challenge is more fundamental than that expressed in an anonymous poem about the experience of growing old:

> When I was young
> I dreamed of the many goals I must reach
> The great deeds I must accomplish
> And the important things I must possess
> Now I know there is only one great thing
> To live
> And see the great light that fills the world

114

List of Illustrations

Plate **Page**

Plate **Page**

Plate **Page**

Plate **Page**

Bibliography

Bonet, S. The Caucasus: Fabled land of longevity. *The Futurist,* Feb. 1977, Vol. 11.

Butler, R. N. Life review: An interpretation of reminiscence in the elderly. *Psychiatry: Journal for the study of Interpersonal* Processes, 1963, Vol. 26.

Butler, R. N. The creative life and old age. In E. Pfeiffer, *Successful Aging* (Ed.), Durham, N.C.: Center for the Study of Aging and Human Development, Duke University, 1974.

Byrne, E. Death and aging in Technopolis, toward a role definition of wisdom, *The Journal of Value Inquiry,* Fall 1976.

Clark, K. Rembrandt's Self-Portraits. *In Proceedings of the Royal Institution,* 1962, Vol. 39.

Clark, K. *The artist grows old* (The Rede Lecture, 1970). Cambridge: Cambridge University Press, 1972.

Comfort, A. *A good age.* London: Mitchell Beazly, 1977.

Comfort, A. *The process of aging.* London: Methuen, 1961.

Dostoyevski, F. *The eternal husband.* Translated by Constance Garnett. New York, MacMillan, 1917.

Guttman, D. Psychoanalysis and aging: A developmental view. In S. I. Greenspar and G. H. Pollock (Eds.), *The course of life: Psychoanalytic contributions toward understanding personality development,* Vol. III, *Adulthood and the aging process,* NIMH, 1980.

Jeffers, F. C., & Verwoerdt, A. *How the old face death.* In E. W. Busse and E. Pfeiffer (Eds.), Behavior and adaptation in late life. Boston: Little Brown and Company, 1969

The Kalevala, Compiled by Elias Lonnrot. Cambridge, Massachusetts: Harvard University Press, 1963.

Kastenbaum, R., & Aisenberg, R. *The psychology of death.* New York: Springer Publishing Company, Inc., 1972.

Malinowski, B. Myth in primitive psychology. In *Magic, science and religion,* Garden City, N.Y.: Doubleday, 1954.

Maves, P. B. Aging, religion and church. In C. Tibbit (Ed.), *Handbook of social gerontology* Chicago: University of Chicago Press, 1960.

McCormick Collins, J. *Valley of the Spirit. The Upper Skagit Indians of Western Washington.* Seattle and London: University of Washington Press, 1974.

Moberg, D. O. Religiosity in old age. In *Middle age and aging,* B. L. Neugarten (Ed.), 497-508. Chicago: University of Chicago Press, 1968.

Moberg, D. O. Religion in later years. In *The daily needs and interests of older people.* A. M. Hoffman (Ed.), 175-91. Springfield, Ill.: Charles C. Thomas, 1970.

Ortega y Gasset, *Man and crisis.* New York: Norton, 1958.

Perry, R. B. *Plea for an age movement.* New York: Vanguard Press, 1942.

Philibert, M. The phenomenological approach to images of aging. In *Soundings: An interdisciplinary journal,* 1974, Vol. 57.

Schopenhauer, A. *Essays.* Trans. T. Bailey Saunders. London, Swan & Co., 1904.

Riley, J.W., Jr. What people think about death. In *The Dying Patient.* C. G. Brim, Jr., et al. (Eds.), New York: Russell Sage Foundation, 1970.

Tolstoy, L. *The death of Ivan Ilych.* Translated by Alymer Maude. New York: New American Library, 1960.

Whitehead, E. Religious images of aging. In S. Spiker et al.
(Eds.), *Aging and elderly: Humanistic perspectives on
gerontology*. Atlantic Highlands, New Jersey: Humanities
Press, 1978.

Wright, C. *Rembrandt: Self-Portraits*. New York: Viking Press,
1982.

Index[*]

Index*